M000289985

REMARKABLE WOMEN

of

RHODE ISLAND

FRANK L. GRZYB & RUSSELL J. DESIMONE

THE
History
PRESS

Published by The History Press
Charleston, SC 29403
www.historypress.net

Copyright © 2014 by Frank L. Grzyb and Russell J. DeSimone

All rights reserved

Front cover, top left: Sarah Parker Whitman. *Courtesy of the Edgar Allan Poe Museum, Richmond, Virginia*; *top right*: Maud Howe Elliott. *From* This Was My Newport; *middle left*: Isabelle Ahearn O'Neil. *Author's collection (FLG)*; *middle right*: Matilda Sissieretta Joyner. *Wikimedia commons/National Portrait Gallery, Smithsonian Institution*; *bottom left*: Summer, 1909 *by Frank Weston Benson*. *Photography by Erik Gould, courtesy of the Museum of Art, Rhode Island School of Design*; *bottom right*: Mary Colman Wheeler. *Courtesy of the Wheeler School.*
Back cover, top: Secretarial students. *Author's collection/FLG*; *bottom*: "Coastline in Little Compton," by Peter Bond.

First published 2014

ISBN 978-1-5402-2462-0

Library of Congress CIP data applied for.

Notice: The information in this book is true and complete to the best of our knowledge. It is offered without guarantee on the part of the authors or The History Press. The authors and The History Press disclaim all liability in connection with the use of this book.

All rights reserved. No part of this book may be reproduced or transmitted in any form whatsoever without prior written permission from the publisher except in the case of brief quotations embodied in critical articles and reviews.

To the past, present and future remarkable women of Rhode Island.

CONTENTS

FOREWORD

L
ike the powerful tides that surge through the Narragansett Bay and give life to Rhode Island's collective identity, the ideas, passions and actions of its inhabitants are natural resources that have been central to the Ocean State's ability to flourish. Rhode Island's unique setting has nurtured generations of citizens whose accomplishments echo across time and reverberate far beyond the state's modest borders. Wagers of war and forgers of peace, builders of our national economy and international trade, voices of social conscience—Rhode Islanders can be justifiably proud of their disproportionate impact on history.

A number of larger-than-life natives of the Ocean State have earned widespread recognition. Mostly men and mostly men of means, the Rhode Islanders whose contributions have been noted by history represent a select subset of the outstanding individuals who have populated the smallest state in the nation. Noticeable by their absence are women. Perhaps it was because our female predecessors did not have the leisure time required to document their own reflections and decisions. Perhaps they did not have ready access to others who recognized and could dutifully report the efforts of incredible women. Or it might be that these women lived in too narrow a time span for the magnitude of their impact to be felt.

Whatever the reason, history has overlooked, attributed to others or treated as a sidebar many of the remarkable feats that Rhode Island's mothers, daughters, wives and partners accomplished as they labored alongside fathers, sons, husbands and neighbors. Our sisters who toiled in

anonymity for the greater good would warmly contemplate this volume, for it is quite obviously a work of love and respect whose priority is to give Rhode Island women the credit they deserve and the focused appreciation that has eluded them. The lessons from the trailblazers, educators, healers, artists and activists whose lives are chronicled in the following pages will allow our daughters and granddaughters, as well as our sons and grandsons, to understand that any era in which we live is only as ordinary or extraordinary as we choose to make it.

SENATOR M. TERESA PAIVA WEED
President of the Rhode Island Senate

ACKNOWLEDGEMENTS

The authors are greatly indebted to the following talented and knowledgeable individuals whose contributions made this book possible: Denise C. Aikens, PhD, staff attorney at Rhode Island Legal Services, Inc.; Susan Areson, deputy executive editor of the *Providence Journal*; Jennifer J. Betts, university archivist at the Brown University John Hay Library; Wendy Chmielewski, PhD, curator of the Peace College at Swarthmore College; Jay Ferreira of the Warren Athletic Hall of Fame; Laurie Flynn and Robert Martin of the Wheeler School; Jeremy Fritsch of Larry Fritsch Cards LLC; Erika Gearing, MLIS, reference library at Johnson & Wales University Library; Jordan Goffin, special collections librarian at the Providence Public Library; Carolyn Magnus, director, and Colleen Lecomte, research librarian, the Portsmouth Free Public Library; Frederick D. Massie, director of communications, *Bar Journal* editor, Rhode Island Bar Association; Russell A. Potter, PhD, professor of English at Rhode Island College; Patricia Redfern, director, George Hail Free Library; Ray Rickman, senior consultant for the Rhode Island Black Heritage Society; Sionan Gunther of the Rhode Island School of Design Museum; Dr. Newell E. Warde, PhD, executive director of the Rhode Island Medical Society; Senator M. Teresa Paiva Weed, president of the Rhode Island Senate and her deputy chief of staff, Marie Ganim; Kate Wells, Rhode Island Collection librarian at the Providence Public Library; and Sarah Zurier, senior historic preservation specialist at the Rhode Island Historical Preservation & Heritage Commission

In addition, a special note of thanks is extended to two highly capable people who contributed their time and effort to critique and edit our numerous drafts: Richard Ficke and Virginia Grzyb.

Finally, not to be remiss, we would like to pay homage to the memory of our mothers, Rose Mary Grzyb and Rose DeSimone, who gave so much of themselves to make us who we are today. In their own special ways, they, too, were truly remarkable women.

INTRODUCTION

When this book was initially conceived, the authors questioned whether two men could do justice to the accomplishments of Rhode Island women. As men with wives, daughters and granddaughters, we felt that if nothing else, we would bring an admiring and refreshing perspective to the subject; whether we did so can only be answered by you, the reader. Early in the project, it became evident that Rhode Island has been blessed with many notable candidates. This made the selection process that much more difficult. In the end, the authors decided that the book should strike a fair balance among well-known and lesser-known women, along with historic figures from the past and those who lived more recently. This measure along with a single binding element—not withstanding their lifetime achievements—is that they all resided in the Ocean State at least at one time or another.

The final selection that appears within includes representatives from many diverse fields of endeavor: artists, athletes, authors, educators, lawyers, poets, politicians and reformers, as well as a few others. Without reservation, these women left an indelible mark on Rhode Island's illustrious history whether on the local, national or international level.

As a clarifying note, the reader is reminded that so much has been written—especially in the past half century—about the likes of Anne Hutchinson (an early Rhode Island colonist and founder of the first settlement on Aquidneck Island), Julia Ward Howe (author of the *Battle Hymn of the Republic*) and Jacqueline Bouvier Kennedy Onassis (first lady and wife of President John

F. Kennedy) that reiterating their stories with nothing new to add made little sense. There were also many other deserving ladies who could have been included but were not because of space limitations.

Keeping the above in mind, the authors beg the reader's indulgence and apologize for those notable women who are not featured. Perhaps they will be in a future offering. But for the women whose stories reside within, each represents an outstanding role model for future trailblazers who are sure to follow.

Chapter 1
NATIVE AMERICANS

A spouse of a woman is a man; the spouse of a man is his livelihood.
—Indian proverb

THE HARD LIFE OF AN INDIAN SQUAW

Nobody knows for certain how many Native Americans populated the region in the early 1600s in the geographical expanse we now call New England. The numbers vary greatly. But what we do know is that in one particular area that is now the state of Rhode Island, there were three main Indian tribes inhabiting the inner forests and the eastern coastline: the Narragansett, the Wampanoag and the Niantic. All were semi nomadic. By far the largest in population were the Narragansett Indians. They lived along the eastern seacoast of the Atlantic Ocean. The second-largest group was the Wampanoag Indians, who claimed a large section of the northwest. The Niantic tribe was the smallest in number, and its habitat was in the southwest perimeter.

Each tribe maintained two communities based on the time of the year. In the summer, men fished in the lakes, rivers and ocean. During the winter, they hunted in the forests for game. Gender roles of Indians from the Rhode Island area were similar to other indigenous tribes throughout New England: men were the main providers of meat and fish, while women farmed the land, cared for the children and made clothing and pottery items. They also did

the cooking. The squaws (married females) harvested white corn, which they ground and pan-fried to make johnnycakes (still offered in select Rhode Island diners today), along with edible roots, beans, pumpkin and squash. They also gathered nuts and berries for consumption during the winter.

Nearly all the squaws grew their hair long. During the summer months, squaws wore wraparound skirts or aprons they either knitted or made from deerskin, which was also used to make moccasins. Their men wore loincloths. In the winter, squaws clothed themselves and their families in coats, leggings and boots, all of which were made by hand using fur or rawhide. Women wore strings of beads around their ankles; the men did not. Both genders wore necklaces made by the squaws.

According to Roger Williams, pregnant squaws in labor made the best of a difficult situation. In his writings of 1643, when comparing squaws to European women, he wrote, "From the hardnesse of their constitution… they beare their sorrowes easier." Squaws worked the farm until the day of delivery; after giving birth, they were up and around within a few days. Two to three days later, they were back working the fields. Though marriages lasted for decades, they were usually not monogamous. Men had several wives, though one squaw was usually the most esteemed and received the greatest affection. Also, divorces were not unheard of. Yet in spite of the above, the wives remained faithful.

Apart from the obvious hardships of living off the land and being migratory people, the Rhode Island Indians seemed content. But then the unthinkable happened. Before the Pilgrims arrived, European explorers came to the New World bringing with them diseases that quickly devastated the Indian inhabitants. Large-scale epidemics wiped out nearly 90 percent of the Indian population. When the Pilgrims landed in Plymouth, Massachusetts, in 1620, what once was an estimated population of twelve thousand to fifteen thousand mainland Wampanoag was reduced to a meager two thousand. By 1675, with more epidemics, battle casualties from King Philip's War, enslavement and escape to other tribes and lands, the number of survivors dwindled to one thousand.

All the tribes were ruled by a chief, known by the Indians as a sachem. Most sachems were men, but history records two female leaders from the Wampanoag tribe: Weetamoo, queen sachem of the Pocasset, and Awashonks, queen sachem of the Sakonnet. As noted by William S. Simmons in his book, *The Narragansetts*, "Some women became sachem when their brothers or husbands died or when there was no brother or other man in the family to inherit the title from a father."

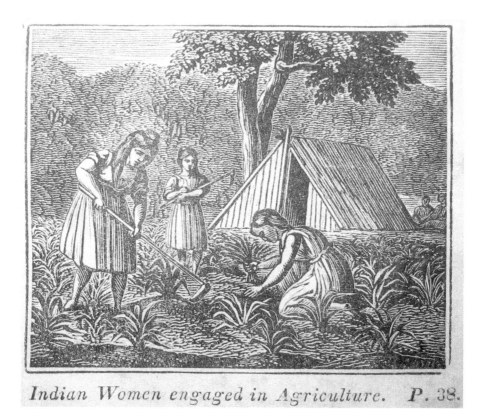

Indian Women engaged in Agriculture. P. 38.

An 1834 wood engraving of Native American women planting their crops. *From* Charles Goodrich's History of the United States. *Author's collection (RJD).*

Weetamoo—sometimes called Tatapanum—was born around 1640. Her name means "sweet heart." Weetamoo's father, Corbitant, was a sachem of the Pocasset tribe in what is today North Tiverton, Rhode Island. Weetamoo was the sister-in-law to Philip for whom King Philip's War is named. During Weetamoo's forty-one years of life, she had five husbands. The first husband, whose name is lost to posterity, died shortly after their marriage. The second, Wamsutta, died suspiciously, possibly at the hands of the English. Because of it, his passing may have been one of the triggers of King Philip's War. Nothing is known about the marriage to her third husband, Quequequanchett, or how the marriage ended. The fourth marriage ended because Weetamoo's husband, Petononowit, sided with the English in the aforementioned war. The fifth and final marriage was said to be with a "handsome warrior" named Peter Nunnuit that lasted

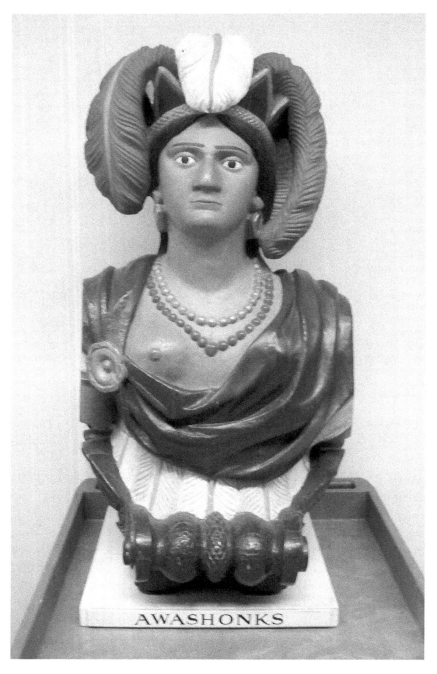

A whaling ship's figurehead of Indian sachem Awashonks. *Courtesy of the New Bedford Whaling Museum; photographed by the author (FLG).*

until her death. Weetamoo may have been made a sachem because she was accomplished in many skills normally performed by men in her tribe. She could hunt, swim and fish and was said to be a skilled diplomat, a talent she used with considerable success when first leading three hundred of her warriors against the English. But the English eventually banded together and, before long, outnumbered the Indians. Weetamoo's warriors were either killed or taken prisoner. While trying to escape across the Taunton River in rough currents in August 1676, she drowned. Period accounts state that the bloated body floated to the surface and was later found by English settlers in Swansea, a nearby town. Before the body was buried, it was decapitated, and the head was placed on a pike in the settlement of Taunton as a stark and visual warning to the Indians against further insurrections.

Little is known about Awashonks. She lived not far from Narragansett Bay in an area that is now called Little Compton, Rhode Island. She became a sachem not by inheritance but because of her leadership skills. She made an enormous mistake, however, when she allied herself with the English settlers, thinking she could increase her power. But when the English won King Philip's War, she was despised by not only the English but her own people as well.

Indian squaws lived a strenuous life, and being sachems and having to concern themselves with the welfare of the entire tribe while trying to preserve the culture and heritage of their ancestors proved a difficult and daunting challenge. Weetamoo and Awashonks learned that lesson the hard way.

A final thought: had it not been for the Indians, the Pilgrims would never have survived their first year in the New World. Arguably, Indians can be credited with many discoveries that were passed on to the first European settlers in America. One in particular not only makes for an interesting story but hits home as well. Native American legend tells of a tribal chief who threw a tomahawk at a tree. As the sap drained, his squaw gathered it up and boiled venison in the liquid. Apparently the tribal chief was pleased with the recipe.

The next time you have pancakes and maple syrup for breakfast, remember to give thanks to the responsible Native American, most assuredly a squaw.

Chapter 2

ACTIVISTS, REFORMERS AND DORRITES

Resolved, that it is the duty of the women of this country to secure to themselves their sacred right to the elective franchise.
—Elizabeth Cady Stanton, first women's rights convention,
Seneca Falls, New York, July 19–20, 1848

DORRITES IN PETTICOATS

Six years before the Women's Rights Conference convened at Seneca Falls, New York, in 1848, women from Rhode Island banded together to promote an extension of suffrage in their home state. But the outcome they were seeking was far different from what a person would generally envision today. In Rhode Island, the ladies were promoting male suffrage for their fathers, brothers and husbands, not for themselves, as the standards of the period dictated that women be excluded from any such political debate. Eventually, the rhetoric became so heated that armed rebellion seemed imminent. While not all women were involved in the suffrage cause—and certainly many were opposed—those in favor were solidly imbedded in the movement. In fact, some were so vocal and committed that they risked imprisonment.

During the early part of 1842, the political movement to allow disenfranchised classes a representative voice in state government degenerated into armed confrontation. This tumultuous period in Rhode

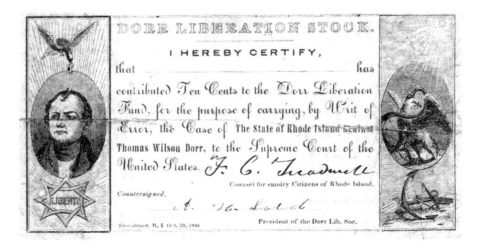

A Dorr Liberation Stock certificate signed by Abby Lord. *Author's collection (RJD).*

Island's history became known as the Dorr Rebellion (named after Thomas Wilson Dorr, the movement's reform leader). With their male relatives' interest in mind, Rhode Island women joined a number of organizations to support the cause. They became known as Lady Dorrites, the most active group being the Ladies Dorric Circle.

Following the failure of the rebellion in June 1842, martial law was declared, and many men fled the state rather than face arrest. With the self-imposed exile, female Dorrites took the lead and agitated for reform. Surprisingly, their favorite method for agitation was the Rhode Island clambake. In so doing, they earned the scorn of the anti-suffrage press. At one such event where the proceedings were dominated by female supporters, the *Atlas* newspaper commented on the group's resolution, writing, "All this was pretty fair for a parcel of spunky women to resolve, while their hen-pecked husbands were sitting and looking on. A nice little petticoat Revolution, truly—and, if they had no body to contend with but those same fathers, husbands and brothers of theirs, we have little doubt that they would come off conquerors."

If the above sarcasm was not enough, the correspondent proceeded to mock the women as "Rhode Island Amazons." He also used phrases such as "Immortal Lady of the Clam-Bake," "Witch of the Enchanted Grove of Medbury" and "Fairy of the Free Suffrage Grotto."

While there were countless Lady Dorrites, four in particular are worth mentioning.

Catherine Read Arnold was born in 1787, a descendant of some of Rhode Island's earliest settlers. At a young age, Catherine's mother died. Her father, a sea captain, seemed always away on a voyage, and because of it, she found herself being raised by two maiden aunts. At twenty-three, she married a Mr. Williams, a descendant of Roger Williams, and moved to western New York. The marriage was an unhappy union. Leaving her husband behind, she and her infant daughter returned to Rhode Island. Much to her credit, Catherine was able to support herself and her daughter by her pen, a most extraordinary accomplishment for a woman in the early nineteenth century. She became a well-regarded writer, publishing numerous works over the years. Following the Dorr Rebellion in 1842, she drafted a searing castigation of Rhode Island's anti-suffrage aristocratic families, titled *Annals of the Aristocracy* (1845). However, in spite of all her writings, it was Catherine's leadership skills during the Dorr Rebellion that separated her from her peers.

At the age of fifty-five, Catherine became the president of Providence's Ladies Dorric Circle (a group of women who met weekly to promote the cause of suffrage throughout the state). Members raised money to support their cause and participated in mass meetings held by the Rhode Island Suffrage Association in Providence and Newport. In the summer of 1841, they took part in suffrage parades, held suffrage fairs to raise money and, following the collapse of the rebellion, held numerous clambakes attended by many thousands. When suffrage men were imprisoned or locked out of jobs by their anti-suffrage employers, it was these same Lady Dorrites who supplied funds to feed their families.

Catherine was also a confidante of Thomas Dorr. Unknown to many, she was one of only three supporters to correspond with Dorr while he was imprisoned, the other two being his mother and his lawyer. Dorr was considered civilly dead by the prison authorities after being sentenced to life in prison in solitary confinement and at hard labor for his insurrection. As such, Dorr was only referred to by his number—fifty-six—and not by his name. As a further humiliation, he was not allowed visitors nor was he permitted to correspond with the outside world. Yet he was able to secret some letters out of prison and to receive them as well. All of this was accomplished through an unidentified confidante who acted as a go-between. If either had been caught in the act, both would have faced severe consequences.

After the rebellion, Catherine wrote an account of her friendship with Dorr. Unfortunately, the manuscript was never published. Today, it resides in the archives of the John Hay Library at Brown University.

Frances H. Whipple was born in 1805 in Rhode Island. She received a good education for a woman, considering the standards of the day. In 1828, while only twenty-three years of age, she published a literary periodical titled *The Original*. Later, she wrote *Memoirs of Eleanor Eldridge* (1838), *The Mechanic* (1842) and numerous other books and poems. In 1840, she contributed to and edited *The Envoy from Free Hearts to the Free*, published by the Juvenile Emancipation Society of Pawtucket. In 1845, she edited *Liberty Chimes*, published for the Ladies Anti-Slavery Society of Providence.

At the time of the rebellion, she was working as the publisher and editor of the *Wampanoag and Operatives Journal* in nearby Fall River, Massachusetts. Unlike Catherine Williams, who provided leadership, or Ann Parlin and Abby Lord, who were actively involved in the rebellion, Frances's primary support was through her pen. Though she wrote articles in the pro-suffrage newspapers, perhaps her greatest written contribution was as author of *Might and Right*, the definitive and only contemporary history of the rebellion from the viewpoint of the suffrage movement. The book not only presented the case of the suffrage movement but also gave a detailed accounting of what Frances believed to be the unfair trial of Thomas Wilson Dorr. It became a much sought-after book, as evidenced by the two editions published within a year of its release.

In 1842, Frances married Charles Green, an artist. Six years later, the marriage failed and the couple divorced. That same year, she became the editor of the *Young People's Journal* of New York City. She also contributed numerous articles to periodicals around the same time. It was during this period that she developed an interest in spiritualism. With this side interest, she contributed articles to a journal called *Spiritual Advisor*. In 1861, Frances moved to California, where she met and married Mr. McDougal. Frances continued to write about spiritualism. Showing her well-rounded interests, she also authored a textbook about botany that, for years, was used in public schools.

Ann Parlin was married to Dr. Lewis Parlin, who is said to be the father of homeopathic medicine in Rhode Island. The Parlins were one of the few husband-and-wife teams actively involved in the rebellion. Ann was active in the suffrage movement before events turned militant, but she took on a prominent role after martial law was declared in April 1842. As secretary of the Providence Ladies Suffrage Society, she held a position of responsibility, but by midsummer 1842, her bold actions and outspoken statements propelled her to an unquestioned leadership role within the suffrage cause.

Ann, along with other suffrage ladies, formed a benevolent association to bring relief to Dorrite prisoners and their families. The ladies of this association visited prisoners in Providence, Bristol and Newport, bringing them food, newspapers and good cheer. They also collected small sums of

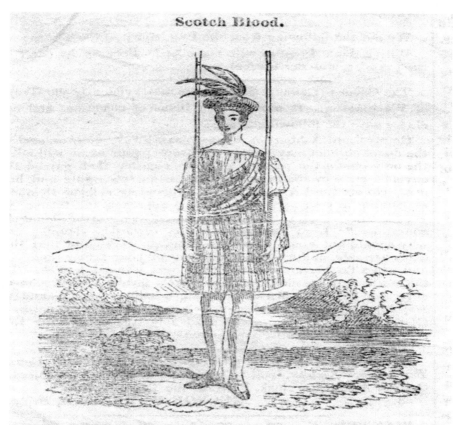

Scotch Blood.

The above is a representation of a notorious " Dorrite" lady of this city, who is descended in a *direct, collateral, lineal, perpendicular* line from some of the Scottish Earls, as she says. She is represented in the dress in which she proposed to go to the late " Dorrite" clam bake on Acote Hll. Besides the two guns which sh was to bear, she was to be armed with fourteen pistols, five carbines and sixteen daggers—all of which should have been ememberd by the engraver, had he not been heedless enough to forget them.

A woodcut depicting Ann Parlin from the *Daily Evening Chronicle*, October 3, 1842, mocking the Dorrite ladies of Rhode Island. *Author's collection (RJD)*.

money for the relief of the prisoners' families. Since many of the prisoners were the sole breadwinners of their families, relief money went a long way toward providing food and clothing. In the press, the first mention of Ann appeared in 1842. By mid-August, she was quoted as confuting the claim in the *Rhode Island County Journal and Independent Inquirer* newspaper that a lady (Ann) had presented a pistol to the breast of a suspected infiltrator at the August clambake. Ann claimed that the spy was apprehended, chalked with rouge upon his back and made to march around the clambake grounds.

Ann again captured headlines just before a Chepachet clambake scheduled for September 28, 1842. Chepachet had been the center of attention the previous June when the rebellion was foiled. A suffrage clambake there was considered a sensitive issue for the charter government. Ann, in her bold fashion, proposed the formation of a women's military company to march onto Chepachet's Acote's Hill. While the military company never formed, some of the verse read at the clambake was indeed bellicose. One poem, titled *Address to the Ladies on Acot's* (sic) *Hill*, while written by "A Suffrage Lady" (the authorship cannot be definitively attributed), is indicative of Ann's rhetoric extracted from some of her letters.

By far, Ann's greatest claim to notoriety occurred on November 4 in New York City. During a three-week stay in the city, Ann attended a meeting of democrats friendly to the suffrage cause of Rhode Island. The meeting held at the Shakespeare Hotel was attended by leading New York City radicals. As one of the speakers that evening, Ann delivered a speech of "long length" in which she gave an account of the acts of the Algerines and their "aristocratic thralldom," the causes of which "induced her to become the champion of the oppressed." Ann, as reported in the *Plebeian*, noted:

> *No one dared to act, but few ventured to speak. In that period of gloom, she* [Ann] *looked round her for a leader to step forward to the rescue of American freedom! None appeared. It was then she recollected that in days of similar discouragement, when the people of God groaned under oppression, not more galling than that which at that time and now, torture the people of Rhode Island, a woman with the high bearing and intrepidity of heroes, enrolled her arms among those of the Judges of Israel.*

The stress of their active roles in the suffrage movement caused problems in the Parlins' marriage. Shortly after Lewis advertised his return to practice and Ann's return from her speaking engagement in New York City, word of marital disharmony was reported in the Providence opposition press. The

primary carrier of this news was the *Providence Daily Evening Chronicle*. By late November, the paper reported, "We understand that a great bobbery has been kicked up in the family of Dr. P., of Dorrite notoriety, in consequence of Madam having made a speech in Shakespeare Hall for the benefit of Mr. [Levi] Slamm...which act, on the part of Madam, the Doctor...deemed very immodest and unbecoming a female."

The stress of the rebellion caused the Parlins to divorce, each going separate ways and both leaving the state.

Abby Lord was married to Henry Lord in 1823. He was much older than her, being in his late fifties at the time of the rebellion and she twenty years his junior. Their marriage was reported in the *Providence Patriot* newspaper on June 25, listing her as Mrs. Abby H. Greene, so it appeared she had been previously married. Abby, like her husband, was active in the suffrage cause. A member of the Ladies Benevolent Free Suffrage Association, she was a correspondent of Thomas Dorr and very aggressive in the suffrage cause. In one instance, she, along with another female suffrage supporter, made an unannounced visit to the home of Governor James Fenner to demand the return of Dorr's personal papers following Dorr's trial in 1844. Unsatisfied with the governor's response and his seemingly insincere promise to bring the topic up before his counsel, she personally checked with the governor's counsel. Her most controversial act, however, occurred in August 1843 during a house poll for eligible men to serve militia duty. Her belligerent response caused her immediate arrest. Thus, she became one of the few female Dorrites to be arrested in the aftermath of the rebellion.

What made Abby Lord remarkable was her initiative to free the convicted rebel Thomas Wilson Dorr from prison. Believing that efforts to seek his release were nonexistent, she quit the Ladies Dorric Circle and formed the Dorr Liberation Society, of which she became president.

A FOOTPRINT ON THE EARTH

Margaret Fuller lived a short life, dying at the age of forty when the ship she was on, the *Elizabeth*, sank in a storm off Fire Island, New York, in May 1850. During her brief existence, she was an editor, educator, literary critic, poet, translator and a leading advocate of equality for women. In fact, she was considered America's most prominent woman of letters in the nineteenth

century. Since her death, numerous books and articles have been written about her and her writings, a strong indication of her importance.

Born on March 23, 1810, in Cambridgeport, Massachusetts, to Timothy and Margarett Fuller, she was the oldest of seven children. Her father was a prominent lawyer, a U.S. congressman (1817–25) and a strict disciplinarian who took a keen interest in the development of her intellect. As such, she was home schooled in the classics. As early as six years old, she began to read Latin. In an autobiographical sketch, Margaret noted that she was not only well versed in the Latin writers of antiquity but also familiar with the works of Shakespeare, Cervantes and Molière. But the expectations and exacting requirements of her father put great pressure on young Margaret, causing her to have what she described as an "over excited mind." "I look back on these glooms and terrors, wherein I was enveloped, and perceived that I had no natural childhood," she continued. At age fourteen, she was sent away to school in Groton, Massachusetts, to attend Miss Prescott's Young Ladies Seminary. Margaret studied there for only a year.

Following the death of her father in October 1835, Margaret took a teaching position in Bronson Alcott's Temple School in Boston. She taught Latin, French and Italian while she also gave private lessons in German, as well as French and Italian, to the daughters of the Boston Brahmin class. Alcott, one of Boston's leading transcendentalists, applied innovative methods of teaching using a teacher-student dialogue modeled after that of Socrates that is now known as Socratic Seminars.

In the spring of 1837, Margaret left Bronson Alcott's Temple School. Later that year, she moved to Rhode Island, where she took a teaching assignment at the Greene Street School in Providence. The school's principal was Hiram Fuller (no relation to Margaret), who like Alcott, was a progressive educator. Margaret became the third female teacher at Greene and, most likely, was its highest-paid employee, as her annual salary was $1,000. Here she taught literature, poetry and history. While none of her students in the short time she spent at Greene went on to fame, Margaret's impact was significant; the majority of the students went on to become schoolteachers themselves. Margaret had designed her classes with a special emphasis on the role of women through the ages, and she had a knack for getting her young female students to enthusiastically join in the dialogue. Truly, she was a feminist long before the term was ever coined.

While in Rhode Island, she continued to formulate her position on women's rights and gender equality. As John Matteson observed in his book, *The Lives of Margaret Fuller*, "To sit in her classroom was to understand

Margaret Fuller. *Author's collection (RJD).*

that womanhood need not lead to a domesticated dead end. Despite the obstacles of convention and orthodoxy, a young woman, too, could converse with philosophers and walk among the gods." And as Judith Strong Albert noted in her article on the Greene School, "As a forerunner of women's

27

studies groups, Fuller and her pupils initiated a form of personal learning, in which they contrasted themselves with other contemporary female poets, writers and educators." The Greene Street School, much like Alcott's Temple School, was an experiment in education though neither school lasted long after Margaret's departure. In a sense, it seems remarkable that a Providence schoolteacher would become the leading female figure within the transcendental movement. Not only did she take a leading role among the transcendentalists, but she also became the best-read woman in America during her short life.

After leaving the state, Margaret went back to Boston, where, in 1839, she became the editor of the *Dial*, then a newly formed periodical for the transcendentalists. Through the pages of the *Dial*, she defended women as men's equal in such essays as "The Great Lawsuit: Man versus Men. Woman versus Women." By 1844, she had moved to New York City, where she assumed the literary editorship of Horace Greely's newspaper the *New York Daily Tribune*. Through it all, she found time to publish her own writings: *Summer on the Lakes during 1843* (1844); her most important work, *Women in the Nineteenth Century* (1845); and *Papers on Literature and Art* (1846). Also in 1846, she resigned her position as literary editor of the *Tribune* to assume the position of foreign correspondent for the same newspaper. This allowed her to travel through England, Scotland and France. The following year, she took up residence in Rome, Italy. Throughout her time in Europe, Margaret sent dispatches that were published in the *Tribune*. Her dispatches were read widely and gave thorough accounts of the revolution taking place in Italy while giving an incisive look at the Siege of Rome. It was in Italy that she fell in love with and married Giovanni Angelo Ossoli. In late 1848, they had a son.

In early 1850, Margaret, her husband and son set sail for America on the ill-fated *Elizabeth*. All members of the Ossoli family perished in a storm that sank the ship. The body of their son washed ashore, but Margaret and her husband's remains were never recovered.

In a letter to William Henry Channing, Margaret once remarked that her writings had "left a footprint on the earth." Those who read and admired her work would agree.

A Sower of Seeds

The nineteenth century was a notable era for reformers who were involved in myriad causes, namely: abolition, temperance, health, education, prisoner and women's rights and suffrage. While abolition was the foremost reform cause during the earlier part of the century, women's rights and suffrage took the lead following the Civil War. A woman named Paulina Wright Davis, whose career and untiring efforts spanned more than forty years, was involved in both.

Born Paulina Kellogg in 1813 in Bloomfield, New York, she was raised by her aunt, who happened to be a strict Presbyterian. However, it does not appear the stern upbringing influenced her as she developed into a freethinker. In her own words, Paulina noted, "I outgrew my early religious faith, and felt free to think and act from my own convictions." In 1833, at the age of twenty, she married Francis Wright of Utica. Both became involved in the antislavery movement.

Sometime after the death of her husband, Paulina made her way to Rhode Island, where she gave lectures on women's health. As Sara Algeo described Paulina in her book, *The Story of a Sub-Pioneer,* "She was a 'real self-starter,' New Yorker by instinct; New Englander by adoption, this 'Play Boy of the Western World' came into conservative Little Rhody when her particular talents were needed most." In 1849, shortly after her arrival, she married Thomas Davis, a wealthy manufacturer and state legislator who would eventually serve as a Rhode Island representative in the Thirty-third Congress (1853–55). From then on, Paulina would spend the rest of her life in Rhode Island working on reform issues.

While Paulina remained involved in the abolition movement, her attention focused on promoting equal rights for women and women's suffrage. As noted by Lillie Chace, daughter of Paulina's close friend and fellow reformer Elizabeth Buffum Chace, her mother admired Paulina's "graceful audacity." Others noted Paulina's significant attributes: a self-starter, an accomplished public speaker and a proven leader. Lillie Chace observed that on arrival in Rhode Island and marriage to Tom Davis, Paulina "dwelt like a sort of foreign princess in Providence. She was too much of a reformer for adoption into the 'society' set in the city, too alien in purpose to suit its great cotton manufacturing families, and too heretical for its college folk. Nevertheless she was a radiant figure in its circle of literary, artistic and reformatory people."

On the evening following a New England Anti-Slavery Association meeting in Boston in late May 1850, Paulina presided over a well-attended meeting

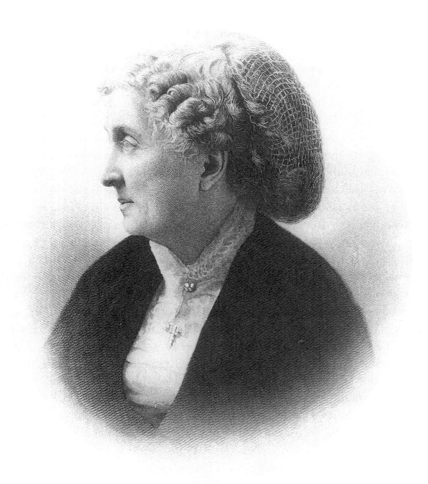

Paulina W. Davis. *Courtesy of the Library of Congress.*

at Melodeon Hall to consider the need for a women's rights convention. Paulina went on to organize and then preside over the first National Women's Rights Convention, which took place in late October of the same year at Brinley Hall in Worcester, Massachusetts. The following year, Paulina again presided over the second National Women's Rights Convention, also convened in Worcester. For most of the decade, she served as president of the Central Committee for these events.

In early 1853, Paulina also became the founder and editor of *The Una: A Paper Devoted to the Elevation of Women.* This Providence-based newspaper

was the first published in the United Stated that was conceived and dedicated to women's equal rights. In the first issue, Paulina noted that she would be "discussing the rights, sphere, duty, and destiny of woman, fully and fearlessly."

Following the close of the Civil War and the successful passage of the Thirteenth Amendment and Fifteenth Amendment to the U.S. Constitution that abolished slavery and gave former male slaves the elective franchise, reformers such as Paulina Davis could now focus exclusively on women's suffrage issues. In 1868, Paulina was again at the forefront of reform activity when she sat on a committee to arrange for a public meeting in Boston on behalf of women's suffrage. The outcome of this meeting was the formation of the New England Women's Suffrage Association, for which she served on the association's business committee. Soon, through the activity of Paulina and her friend Elizabeth Buffum Chace, a Rhode Island affiliate to this association was formed: the Rhode Island Women's Suffrage Association (RIWSA). Paulina would become its first president. Soon after the formation of RIWSA, a split occurred nationally within the women's suffrage movement; one faction within the National Women's Suffrage Association broke off to form the American Women's Suffrage Association. This fracture led to repercussions within the Rhode Island organization as members took sides on the issue of whether to support or reject the constitutional Fifteenth Amendment. Paulina, like Susan B. Anthony and Elizabeth Cady Stanton, opposed the amendment. Her friend, Elizabeth Chace, took the opposing view and sided for ratification. The schism between factions wreaked havoc within RIWSA, and shortly thereafter, Elizabeth Chase assumed the presidency of the organization. Paulina, now in failing health, faded from any further involvement. However, she found time and energy to compile and write *A History of the National Woman's Rights Movement*, published in 1871.

In August 1876, just two weeks after her sixty-third birthday, Paulina Davis died in Providence. Unfortunately, like so many of the early women suffragists, she did not live to see the passage in 1920 of the Nineteenth Amendment to the U.S. Constitution that afforded women the right to vote. However, through her example and commitment, Paulina did pave the way for the next generation of women suffragists to follow. As Sara Algeo noted in her history of the women's suffrage movement in Rhode Island, "Some sow the seed—others gather it in the harvest. Paulina Wright Davis was one of the sowers." In 2002, Paulina was inducted into the National Women's Hall of Fame, a long overdue but deserving honor.

TRY, TRY AGAIN

Upon return from the New England Women's Suffrage Association organization meeting held in Boston on October 23, 1868, two Rhode Island Women, Paulina Wright Davis and Elizabeth Buffam Chace, established the Rhode Island Women's Suffrage Association just two months later. Elizabeth, a Quaker and a fervent abolitionist, became its first president. For the next forty years, the Rhode Island Women's Suffrage Association functioned as the sole driving force behind women's suffrage in the state.

After repeated attempts to have the state legislature consider a referendum on women's suffrage, the Rhode Island lawmakers acquiesced and submitted a bill for consideration. Not surprisingly, on April 6, 1887, the male-dominated assembly defeated the referendum by a vote of more than three-to-one. Even the state's largest newspaper, the *Providence Journal*, opposed the measure. That rejection caused the organization to establish its own publication: the *Woman's Journal*. When Elizabeth Chace was told about the outcome at her home while recovering from surgery, she said, "Well, what shall we do next?" Not to be undaunted, the tenacious lady continued her crusade for women's rights and other important issues until her death in 1899 at the age of ninety-three.

As the years passed, the Rhode Island Women's Suffrage Association continued to lobby for the franchise. A suffrage bill was presented each subsequent year for vote to the state legislature, though no referendum of the kind ever passed.

In the meantime, during the late nineteenth century, a number of local women's clubs—with and without church affiliation—sprang up in cities and towns throughout the state. In Newport, a black women's club was created to

Elizabeth B. Chace. *From* Elizabeth Buffum Chace: Her Life and Its Environment. *Author's collection (RJD).*

WOMEN
OF
RHODE ISLAND

YOU

Can Vote for the next
PRESIDENT OF U. S.

IF

YOU REGISTER
At your Town or City Hall
GO AT ONCE!

The Clerk there will give you the needed information
as to details

Then Ask for the Ratification
of the Suffrage Amendment

Rhode Island Equal Suffrage Association
234 Butler Exchange
Providence

A broadside in support of the Rhode Island women's suffrage movement. *Author's collection (RJD)*.

address problems not solely limited to women's suffrage. Issues included health and sanitation, education and, of course, racial equality. In the final analysis, by keeping their issues in the limelight at the local level, organizations such as these helped the suffrage movement when most needed.

In December 1907, the College Equal Suffrage League was established. Its goal was to reeducate citizens about their cause and to gain a larger representation from women who had not previously joined their efforts. Six years later, the Rhode Island Women's Suffrage Party was formed. But it was not until 1915, when the groups merged and formed the Rhode Island Equal Suffrage Association, that they became a driving force for change within the state. More focused than ever, the organization addressed a number of moral and social issues, including better educational opportunities, protective child and female labor laws, improved immigration legislation and, as part of the temperance movement, the prohibition of alcoholic beverages.

Then it happened. After a long and arduous fight, the Rhode Island legislature permitted women the franchise in 1917 to vote for presidential candidates—but not without reservation. Women were given the right to vote but *only* for presidential elections. After the formation of the National League of Women Voters in 1920 that united the state's suffrage members into a strong unifying purpose, the League of Women Voters of Rhode Island was established on October 8, 1920, to continue its work at the state level. Then the glorious day arrived. Finally and with considerable fanfare, the U.S. Congress passed the Nineteenth Amendment on August 18, 1920, guaranteeing women's right to vote.

Today, the League of Women Voters of Rhode Island continues to be a driving force within the state. The league's mission has expanded significantly from its inception and through the efforts of its dedicated and courageous members, a number of local reforms have taken place. They include judicial restructuring, improvements to state tax laws and allocation and the passing of the Direct Primary Bill and the Home Rule Bill, just to mention a few.

Rhode Island women have come a long way since 1868. If alive today, Paulina Wright Davis, Elizabeth Buffam Chace and all the other courageous women who laid the groundwork and labored for the cause would surely say without reservation, "It was well worth the effort."

Chapter 3

THE LITERATI

Life can't ever really defeat a writer who is in love with writing, for life itself is a writer's lover until death—fascinating, cruel, lavish, warm, cold, treacherous, constant.
—Edna Ferber, A Kind of Magic, *1963*

QUOTH THE ENGAGEMENT, NEVERMORE

Because of a heart condition, life was not easy for the young lady from Providence. Sarah spent a good portion of her earthly existence breathing ether through a dainty handkerchief. The prescribed treatment was an accepted eighteenth-century remedy for such an illness. For Sarah, the effects were instantaneous: an overall sense of euphoria and disassociation from reality—present-day addicts define the sensation as a psychedelic experience. But for Sarah and others who partook, there were side effects. While masking the condition, the user's body would generate a foul-smelling odor that was best described as "deathly-sweet." That was a minor issue. The greater concern dealt with the ever-present danger of overdosing. To some extent, Sarah's use of ether and its effect on her well-being may explain her later-in-life interest in science, transcendentalism, mesmerism and the occult.

Sarah Helen Power was born in Providence on January 19, 1803. Little is known about her mother, Anna Marsh. Her father, Nicholas Power, once a prosperous merchant, went bankrupt during the War of 1812. As the

story unfolds, Power was captured by the British during a trip to the West Indies but was subsequently released. He was not seen again by his family for about twenty years. Why the long hiatus and why he decided to return is anyone's guess. At the time of his capture, Sarah was only ten years old. Upon his mysterious return, Power took up a separate residence from his wife, a practice considered rather shocking in the 1800s. Not surprisingly, newspapers took great liberties in making him the laughingstock of the community—and for good reason. Power not only had deserted his family but after his return was often seen disheveled and inebriated as well. He became an easy target. Enough said.

During her father's protracted absence, Sarah was raised a Quaker. In 1828, she married John Winslow Whitman, poet and writer. Because of his capacity as a co-editor of two journals, Sarah was afforded the opportunity to publish a sampling of her poetry. But John died five years later. There were no children. In the meantime, Sarah's poetry began to gain wide acceptance in New England and eventually among critics throughout America. Her work propelled her into an elite category of best-read female poets. It was during this period that Sarah began associating with other intellectuals with similar taste.

Soon she became interested in transcendentalism. That inspired her to publish a number of essays defending Romantic and transcendentalist writers. But she did not stop there. Sarah also became an activist for progressive education, woman's rights and universal suffrage. However, it was her dabbling in the occult that sparked her greatest curiosity and eventually the style of clothing she wore. She was often seen walking around Providence in black dress, a style and color normally reserved for mourning. Adding to her eerie appearance was a coffin-shaped charm strung around her neck. Though there is no concrete evidence, Sarah was said to have conducted séances at her home, a plausible assumption in light of her spectral interests.

Years passed. It was 1845. During a midsummer day, Sarah's path would cross from a distance with someone who held similar interests in writing and the metaphysical. Edgar Allan Poe was in the city to attend a lecture given by Frances Sargent Osgood, an American poet admired and, most likely, loved by Poe, though both were married at the time. Either en route or upon return, they passed Sarah's house. She was standing in her rose garden, situated in her backyard. Though Poe saw her, he declined to be introduced, even though he may have been smitten by her appearance. They would meet three years later after Sarah sent him a poem she composed. Familiar with Poe's work, Sarah was fascinated by his tales of the macabre.

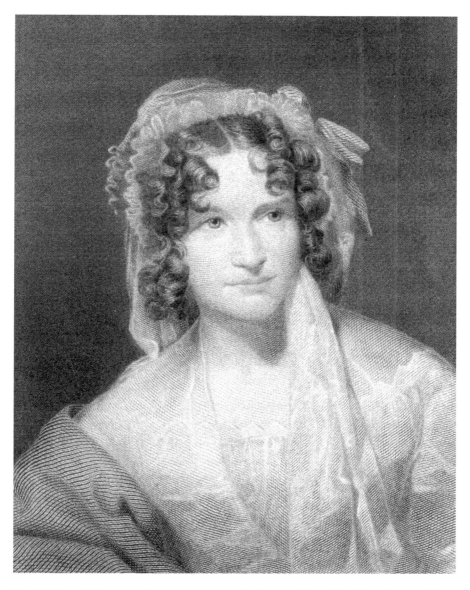

Sarah Parker Whitman as she appeared when she first met Edgar Allan Poe. *Courtesy of the Edgar Allan Poe Museum, Richmond, Virginia.*

Poe returned the favor by sending her a previously written poem titled "To Helen." Without a signature, Sarah may not have known who sent it and, therefore, did not respond. After three months without a reply, Poe drafted a new poem using the same title, "To Helen," but this time his identity was

thinly concealed when he made reference to seeing her in the rose garden within one of the verses.

Over the ensuing months, a romance began to blossom, despite Poe's concern about Sarah's friends. They were mostly transcendentalists, and Poe did not take kindly to their beliefs. Yet letters continued to be exchanged, and the romance intensified. Then on a December evening in 1848 while lecturing in Providence, Poe recited a poem by Edward Coote Pinkney while directing his gaze exclusively in Sarah's direction. Sarah may or may not have blushed, but what is known is that she did accept Poe's unique marriage proposal. But there was a stipulation. Poe would have to abstain from alcohol. Though he agreed, within days, he broke his promise. Further complicating the situation, Sarah's mother discovered that Poe was pursuing his childhood sweetheart, Annie Richmond. Knowing Poe's lascivious ways, she demanded that Sarah place all of her possessions in her mother's name. Whether the warning was heeded remains a mystery. Eventually, Sarah did find out about Poe's continued drinking. Whether Sarah's mother broke the news or an anonymous friend did makes no difference. The marriage was called off. A year later in Baltimore, Poe was found lying in a gutter. Shortly after being brought to a nearby hospital, he died, presumably of alcohol poisoning and exposure.

Sometime in 1860, and in spite of Poe's shortcomings, Sarah continued to support his work by defending him in writing against a plethora of critics. It was an amiable, if not surprising, gesture on her part. In her book *Edgar Allan Poe and His Critics*, she began with the opening statement: "Dr. Griswold's memoir of Edgar Poe has been extensively read and circulated; its perverted facts and baseless assumptions have been adopted into every subsequent memoir and notice of the poet, and have been translated into many languages. For ten years this great wrong to the dead has passed unchallenged and unrebuked." She then proceeded to dispute all of Dr. Griswold's accusations. But in many ways, Poe's reputation had been so badly tarnished that reversing all of the damage was nearly impossible. She had done her best.

As the years passed, Sarah Helen Power Whitman—still retaining both her family and married surnames—continued her work supporting women's rights and social reform. She lived to the age of seventy-five before passing away at the home of a friend in the city. When her will was probated, she left significant funds to allow for the publication of poems by herself and her sister. She also left money to the Providence Association for the Benefit

of Colored Children and the Rhode Island Society for the Prevention of Cruelty to Animals.

Warming Both Hands Before the Fire of Life

Born in Boston on November 9, 1854, the youngest of four daughters and the fifth of six children, Maud Howe joined a family who had garnered significant wealth and worldwide recognition. On the paternal side, Maud's roots could be traced back to Roger Williams, the founder of Rhode Island. Later, during the colonial era, two of her ancestors, Richard Ward and Samuel Ward, served as Rhode Island governors. Maternally, Maud could credit Francis Marion, a Revolutionary War hero known as the "Swamp Fox" in her lines (Marion would eventually be extolled as the "Father of Modern Guerrilla Warfare"). During her youth, Maud's parents would also make a significant contribution to the family's illustrious legacy.

Maud's father, Dr. Samuel Gridley Howe, was a prominent physician, abolitionist and social reformer who founded the Perkins School for the Deaf. Her mother, Julia, could also claim a number of significant accomplishments. She was a prolific author, an avid poet, a champion of women's suffrage and a peace activist. Under her mother's influence, Maud received a private education both at home and in Europe. While overseas, she visited numerous museums and art galleries, which stimulated her interest and appreciation for the arts.

Like that of her siblings, her life was privileged. But Maud blazed her own trail. While living in Rhode Island—first with her family at a summer vacation home in Portsmouth and later with her husband, English artist John Elliott, in Newport—Maud blossomed. As an independent thinker, she is credited with writing over twenty books. According to Nancy Whipple Grinnell, many of her works "challenged nineteenth century gender roles" (a small collection of Maud's papers and scrapbook clippings are retained at the John Hay Library at Brown University). Her most notable work, co-written with her sisters Laura E. Richards and Florence Howe Hall, titled *Julia Ward Howe 1815–1910*, received wide acclaim and was awarded the first Pulitzer Prize for a biography in 1917.

Capitalizing on her family's legacy and her own "unquenchable fire," she found endless success as a Newport socialite where her natural beauty (her

Maud Howe Elliott. *From* This Was My Newport. *Author's collection (FLG)*.

grandmother Patty Gridley was said to be "the most beautiful woman of her day"), persuasive charm and keen intellect sustained her in a community filled with the rich and famous. After her return from Italy, where she had been living with her husband for a decade, and until her death, Maud's presence at social events and fundraising activities in Newport was usually requested, and when feasible, the request was routinely honored.

Besides her social and literary successes, Maud never lost her love for the arts. Because of that devotion, she was instrumental in establishing the Art Association of Newport (now called the Newport Art Association). It remains today as a testament to her love of the craft (The art museum on the corner of Bellevue Avenue and Old Beach Road operated by the association continues to attract visitors from around the world). Maud also co-founded the Society of Four Arts in Palm Beach, Florida, another of her organizations that is still in existence today.

After World War I, Maud served on the committee to secure funding for the erection of a World War I monument to honor veterans that served during "the war to end all wars." The Miantonomi Tower (named after a Narragansett chief), along with thirty acres of land, is still enjoyed by residents for year-round recreational activities. Through a 2005 easement, the park was acquired by the Aquidneck Land Trust to ensure continued enjoyment by future generations.

There is something else left to be said about Maud and her family. Maud's mother, Julia, was none other than Julia Ward Howe, who became an instant celebrity for her poetic work "The Battle Hymn of the Republic." The words set to the tune of *John Brown's Body* helped galvanize Union sentiments during the Civil War.

Before her death in Newport on March 19, 1948, Maud Howe Elliott strongly voiced her love for Rhode Island and especially her years spent on Aquidneck Island when she said, "Newport has been the home of my people from the beginning. I belong to it and it belongs to me." Maud's remains lie at Mount Auburn Cemetery in Cambridge, Massachusetts. The inscription on her gravestone reads: "I warmed both hands before the fire of life."

That she did.

ARTS AND ARTISTS

The artist must possess the courageous soul that dares and defies.
—*Kate Chopin,* The Awakening and Selected Stories, *1899*

IN HER FATHER'S FOOTSTEPS

Gilbert Stuart of Saunderstown (North Kingstown), Rhode Island, was a celebrated portrait painter from the eighteenth century who today is best known for his unfinished work of George Washington. If you would like to see an example of his artistic talent, simply open your wallet and take out a one-dollar bill. The engraved image of George Washington that has been featured on the obverse of the currency for over a century was inspired by Gilbert Stuart's painting.

Gilbert and his wife, Charlotte Coates, had a large family, as was the convention in those days—twelve children (five sons and seven daughters). Their youngest, Jane, was born circa 1812. Over the ensuing years, Jane turned into an accomplished painter in her own right, but not because of any formal training by her father or any other painters she knew. Though favored by her father, he preferred to call her "Boy." Why? No one is exactly sure, but a writer named Meg Nola suggested in an article titled "American Artist Jane Stuart, Daughter of Painter Gilbert Stuart," it may have been "to belittle her femininity and keep her in a subservient role." Gilbert was also known to be onerous, something the family had to apologize for on

numerous occasions. He also drank heavily and had a propensity to spend far above his means.

Of the Stuart children, Jane was allowed to help with the chores in his studio and grind pigment. Later, she was the only child taught by her father to paint portrait backgrounds (there is no evidence that she was given any other artistic lessons by him). But her time in the studio was well spent by watching her father instructing his students. Before long, Jane was not only allowed to finish his paintings—a common practice at the time—but also to copy his completed works for future sales (copies of presidential portraits usually sold for $100).

A painting by artist Jane Stuart titled *Little May*. The portrait is of Mary Le Mont Wilbur, who was eighteen months old at the time. *Courtesy of the Portsmouth Free Public Library; photographed by the author (FLG).*

Despite some historical evidence to the contrary, Gilbert must have contributed to his daughter's artistic education. At the age of fifteen, she exhibited one of her paintings at the Boston Athenaeum, something Jane would have been unable to arrange by herself. A year later, Gilbert died in 1828 at the age of seventy-two. He left his family destitute, having an estate valued at only $375. With no expendable income, the patriarch had to be buried without a headstone. Because Jane had demonstrated marketable skills as a painter, she was now faced with becoming the major breadwinner for the family. She did the only thing she knew—copied her father's portraits, especially those of George Washington, and painted many of her own works.

Jane eventually moved to Boston, where it became easier to sell her paintings. She also started painting narrative genre works, Bible scenes and miniatures. Then in 1850, her studio was destroyed by fire. Though many paintings were lost, she was not discouraged. She returned to Rhode Island and settled in Newport, where she painted and entertained almost until her death. In spite of everything, Jane defended her father's demeanor until she died in 1888. She admitted he had an "irritable temperament" but said that his nature was dictated by the overwhelming flow of visitors to his studios who continually disrupted his work.

Jane was said to look much like her father, with sharp features that made her appear rather plain and unattractive. Yet she used her appearance as an advantage in Newport society by joking about her less-than-comely appearance. As Meg Nola would later write, "While the true scope of her actual potential beyond her father can never be known, her efforts as a dutiful daughter show a notable gift and the ability to make the best of the artistic hand she was dealt."

Today, Jane Stuart's work is prized by collectors. One of her cherished paintings hangs in the Kennedy School of Government at Harvard University. Other works can be seen at the Redwood Library, the Newport Historical Society, the Preservation Society of Newport County, the Newport Art Museum, the Boston Athenaeum, the Museum of Art at Rhode Island School of Design and the Peabody Essex Museum. No one knows for certain how many of her other paintings are in the hands of private collectors.

THE GIRL WITH BIG DREAMS

Viola Davis was a southern girl by birth. Born on August 11, 1965, on the site of a former plantation in St. Matthews, South Carolina, Viola and her family moved to Central Falls, Rhode Island, only a few months later. When reminiscing about her past, Viola remembers her childhood as a time of "abject poverty and dysfunction." The same feeling probably was indicative of many other adolescents from the town.

Central Falls was an economically depressed area near Pawtucket and Providence when Viola and her family first arrived. Today, things have not improved much as the town still suffers with high unemployment, thus creating an extreme hardship for those struggling to make ends meet. But for some indeterminate reason, the smallest municipality in the state has retained an indomitable spirit and unwavering passion to survive. Some of that inner strength has to be credited to Viola's continued involvement in the community and its educational system that is filled with minorities and first-generation Americans.

During her years at Central Falls High School, Viola became involved in the arts. After graduation, she attended Rhode Island College and majored in theater before moving on to the Julliard School. She had not only found her passion but also strove to improve in her chosen field.

Viola's first professional stage performance took place at Trinity Repertory Company in Providence, where she acted from 1988 through 1995 before moving on to Broadway. In 2001, she won a Tony Award and a Drama Desk Award for her performance in *King Hedley II*. A year later, she would win a second Drama Desk Award for the stage production *Intimate Apparel*. She also acted in several television series in subsequent years. In June 2010, Viola won a second Tony Award in the stage production *Fences*. Her greatest achievement in acting came a year later when she received two Screen Actors Guild Awards and an Academy Award nomination as best actress for the movie *The Help*. In addition, she won a Golden Globe Award for the same movie. After that, the awards kept coming. But she didn't stop there. Today, Viola and her husband, Julius Tennon, own their own production company: JuVee Productions. But it is more than Broadway and Hollywood stardom that makes Viola's life appealing. What distinguishes her from many others in her profession is a desire to never forget her roots.

In June 2012, Viola accepted an offer to speak at her high school alma mater. At the graduation ceremony, she talked about many things. But an incident that happened to her in her childhood and relayed at the event is

Actress Viola Davis as she appeared before Rhode Island lawmakers in support of an animal welfare bill. *Photographer: Bob Thayer, 2013.* Providence Journal, *May 28, 2013.* *Copyright © 2013, the* Providence Journal. *Reproduced by permission.*

worth repeating. In the third grade, a classmate kept calling her the N-word. She took it as a challenge. The boy had a reputation as the fastest kid for his age in Central Falls. Viola challenged him to a race. She took off her shoes that were a size and a half too small and ran with socks full of holes. The race ended in a tie; a moral victory for Viola and perhaps a lesson for the young boy. Viola never forgot the incident and used its lesson to tell the graduating seniors: "You gotta be in the race, no matter what…win or lose." Later, she added, "I know the road ahead of you. I know all the obstacles that are placed in your path, living in Central Falls. That's nothing compared to what you're going to face in life."

During an interview conducted in 2010 by Matthew Rodrigues (now an entertainment reporter for *POPSUGAR LIVE!*), Viola briefly talked about her small-town values, adding, "I was the girl from the small town with big dreams, and they are slowly but surely coming to fruition." Few who have seen her remarkable performances would argue otherwise.

Apart from the publicized donations and personal appearances, no one knows for certain how many other good deeds have been performed by Viola, nor will they probably ever know. But the facts remain: whether owed or not, the southern-born actress with northern roots has repaid the community of Central Falls and the state of Rhode Island tenfold.

Chapter 5

EDUCATORS

*Teachers, who educate children, deserve more honor than parents who merely gave
them birth; for the latter provided mere life, while the former ensure a good life.
—Aristotle, quoted in* Diogenes Laertius's Lives

A LASTING LEGACY

Sarah Elizabeth Doyle was the third of seven children born to Thomas and
Martha (Jones) Doyle. Sarah's elder brother Thomas would serve as the mayor
of Providence for eighteen years and witness a doubling of the city's size while
in office. He also held the distinction of being the longest-serving mayor of the
city until his record was broken in the last half of the twentieth century. As for
Sarah, she was educated in the public schools of the city, attending Elm Street
Grammar School before entering the Girl's Department of Providence High
School in 1843, the year the high school first opened. Sarah never went to
college. In her day, only a handful of women did so. Later, through her efforts
and involvement as a leader in the women's movement, doors would finally be
opened for future generations of women wanting to attend college. Today, and
rightfully so, Sarah Elizabeth Doyle is considered the foremost champion of
women's higher education in Rhode Island. This is her story.

Upon graduating from high school in 1846, Sarah taught in private
schools. In 1856, she started teaching at Providence High School and, in

1872, became principal of the school's Girl's Department. She held that position until her retirement at age sixty-four in 1892. It was during these years as principal that Sarah advanced the idea of women's higher education and entered on a mission that, to most, would seem an impossible dream.

A painting of Sarah Doyle by Bryan Konietzko. The original portrait painting that inspired this image was stolen from Sayles Hall at Brown University in 1997. It has yet to be recovered. *Courtesy of Brown University, John Hay Library.*

Sarah was largely responsible for the formation of the Rhode Island Society for the Collegiate Education of Women (RISCEW) and served as its first president. She was also active in a number of newly formed women's organizations that looked to advance women's interests. During the last quarter of the nineteenth century, when the push for women's rights took on significant momentum, many new organizations were formed statewide. At this time, it seemed Sarah was in the midst of it all. It was through her association with other women's organizations that advancements were being made. For example, the Rhode Island Women's Club was organized in 1876 to provide courses, lectures and concerts for instruction and entertainment of women. Sarah was one of the founding members. While these associations were involved in a number of benevolent projects, Sarah's primary interest proved to be women's higher education.

Throughout her life, Sarah proved to be a natural leader and administrator, becoming actively involved in a number of women's organizations. Shortly after the Rhode Island Women's Suffrage Association was organized in 1868, Sarah became a member. And as a member of the Rhode Island Women's Centennial Committee, she endorsed using the monies remaining from that committee's funds to help establish the Rhode Island School of Design (RISD). She was also a charter member of RISD and served as its secretary for more than twenty years.

In 1884, Sarah was the first woman to preside over a session of the National Education Association. She also worked tirelessly as a founding member of the Rhode Island Women's Club and the Rhode Island Federation of Women's Clubs. Surprisingly, she also found time to be active in church organizations, presiding as president of the National Alliance of Unitarian and other Liberal Christian Women at the First Congregational Church of Providence. Through her long career and her many civic involvements, Sarah was first and foremost committed to college education for women, as her presidency of RISCEW attests.

By 1885, Sarah was already active in pursuing college careers for her young female students. That year, she encouraged Alice D. Mumford, a promising scholar, to apply for admission to Brown University. Unfortunately, the university's president, Ezekiel Robinson, was not ready to accept females, and young Alice was denied admission. However, in 1889 after the appointment of Elisha Andrews as the new Brown University president, the policy of exclusion was about to change. Andrews was a liberal-minded administrator, and through their hard work, Sarah and her RISCEW members were able to prevail on the university to allow women to take the same entrance

examination as their male counterparts. In 1891, the women who passed were admitted to the university but under the stipulation that they attend separate classes. While acceptance of these first women was not a guarantee of full acceptance, over the next few years, the university donated land for a women's college. However, funding to construct a new edifice would have to come from sources outside the university. Through the efforts of various women's clubs, a Committee for the Women's College Fund was formed. Leading the fundraising campaign, as to be expected was Sarah Doyle.

When construction was finally completed in 1897 and dedication ceremonies held in front of the new building, it was Sarah Doyle who handed the keys of the building over to President Andrews. The building was named Pembroke Hall in recognition of Rhode Island's founder, Roger Williams, who attended Pembroke College at Cambridge University. This tribute was made to pay homage not solely to Williams but also in recognition of Pembroke College's founder, a woman named Marie de St Pol, widow in 1347 of the Earl of Pembroke. This was a subtle but nonetheless well-understood recognition of women's role in promoting collegiate education. In 1894, the university graduated its first class of women, Mary E. Woolley and Anne T. Weeden. Mary Woolley would go on to become president of Mount Holyoke College in 1900.

Sarah's efforts did not go unrecognized. In Providence in 1894, the Sarah E. Doyle Club was founded by a large group of women educators. The club was open to any woman regularly employed as a teacher in a public or private school of Providence. The club's objective was the mutual assistance and culture of its members, especially in the line of their professional work. From its beginnings, the club raised funds annually to support the building of Pembroke Hall at Brown. The organization lasted well into the twentieth century. Also in 1894, Sarah Doyle became the first woman to receive an honorary degree from Brown University, awarded in recognition of her service to Rhode Island's women.

While Sarah was keenly interested in higher education for women, she also was active in a number of other gender-related efforts. Today, every young woman graduating from a Rhode Island institution of higher learning is a testament to Sarah Doyle's efforts to bring equality of education to women. Most fittingly located on the campus of Brown University is the Sarah Doyle's Women's Center. Established in 1974, the center seeks to provide a place where members of the Brown University community can gather to discuss gender issues. Though Sarah died in 1922, her legacy continues to inspire other generations of like-minded women whose strong intellect and determined purpose has made a better future for all.

AN EDUCATIONAL VISIONARY

Mary Colman Wheeler was born on a farm in Concord, Massachusetts, on May 15, 1846, to a family who could trace its roots back to the earliest settlers of Massachusetts. With friends and neighbors like the Alcotts, Emersons, Hawthornes, Peabodys and Thoreaus, her childhood was far from mundane. Arguably, associating with such luminaries must have had a long-term effect on her inner drive and long-term aspirations.

Mary A. Shaw founded the Miss Shaw's School for Young Ladies in Rhode Island where Mary Wheeler first taught. *From* A History of Miss Abbott's School. *Author's collection (FLG).*

After graduating from Concord High School, Mary attended Abbot Academy in Andover, Massachusetts, a preparatory school for young women. In 1973, after merging with Phillips Academy, a young men's school, Abbot ceased to exist as a separate entity, as Phillips immediately became coeducational. After graduating, Mary was hired to teach mathematics and Latin in the public school system in her hometown. Then an opportunity arose that she found too good to refuse. Mary was asked to become a teacher at Miss Shaw's School for Young Ladies in Rhode Island. After contemplating the offer, she traveled to Providence and accepted the position. The school was founded by Mary A. Shaw in 1860 and offered courses in French, German, Italian, Latin, drawing, music, elocution, gymnastics, physical sciences and bookkeeping.

During her youth, Mary not only aspired to become a teacher but also developed a keen interest in art. In the early 1870s, while following her dreams, she traveled to Europe to study painting. The first stop on her journey was in a small rural village in central Germany, where she visited her sister Sarah and her sister's family. Seeing them must have been delightful, but a totally different experience awaited her that would send shivers up anyone's spine. One particular day, Mary was sketching an image of a bridge when she was approached by a government official. Most likely, Mary attracted attention because of the way she was dressed in masculine attire and because she was a stranger in the area. Surmising that she was a man (how this was determined remains conjecture), the official placed her under arrest as a French spy. The charge was for clandestinely making a military map to aid the French army. The entire scenario may seem preposterous to the casual reader, but the reader needs to understand the climate of the times as France and Germany were enemies during the Franco-Prussian War. Fortunately, Mary's sister came to her defense, and she was freed before any official investigation was conducted.

Mary's trip to Europe was not all that she had expected, especially in regard to enhancing her art education. A bit disappointed, she returned to the States and took a teaching position in Concord, Massachusetts. During her tenure, she suffered a nervous breakdown and was incapacitated for eighteen months. After recuperating, Mary returned to Providence to teach for another year before returning for a second time to Europe for more art study. As many young women did during that time, she settled in culturally rich Paris, where she studied art (neoclassicism) for six years. According to Robert Martin, historian at the Wheeler School, "Her crowning achievement in Paris came in

Mary Colman Wheeler at the age of thirty-two about the time she was visiting London and Paris. *From* Mary C. Wheeler: Leader in Art and Education. *Courtesy of the Wheeler School.*

1880, when her drawing was accepted for exhibition at the Paris Salon, the most important juried exhibition of the year."

After a rewarding interlude in France, Mary returned to Providence refreshed and ready for the challenges that lay ahead. In 1883, she opened her first art school—"Miss Wheeler's Studio"—where she taught drawing and painting exclusively to women. In homage to Mary, today the advanced art school is called unpretentiously "Studio."

Beginning in 1887 and continuing until 1904, Mary took her students to France during the summers. The only exception was when she remained stateside in Old Lyme, Connecticut. Both in Paris and in the surrounding countryside, the students not only learned the language but also studied painting techniques and art history. In the summers from 1907 to 1912, Mary traveled with her students to Giverny in northern France. While there, Mary leased property next to Claude Monet, the famous painter. Period accounts state that she and her students were occasional dinner guests at the Monet residence and that Monet visited Wheeler's painting class on several occasions. It was during this time (1905–1912) that she developed an interest in impressionism that remained with her for the rest of her life. Also, Mary came to the realization that her students "deserved more than a finishing school approach to education."

Back in the States, Mary continued to teach art while adding college preparatory courses to the curriculum. As time passed, the school continued to grow in stature. Mary could never have dreamed that as the school's first headmistress, she would faithfully serve the institution for another thirty years. As word spread and enrollment increased, Mary began to look for additional space. In 1893, she purchased the Froebel Kindergarten. Soon the school would have two campuses: one in Providence and the other on farm property in Seekonk, Massachusetts. It consisted of 120 acres. The pastoral location is known affectionately today as the "Farm" and includes indoor athletic facilities, outdoor playing fields, a conservation area and a conference center. With the acquisition, the school name was changed to Miss Wheeler's Town and Country School. It was a fitting name for an institution with a diverse two-location campus.

In 1900, 1904 and again in 1908, at the International Congress of Drawing, Mary served as an American delegate. As her school expanded its enrollment and became better known outside the confines of Rhode Island, so did Mary's reputation as an innovative educator. In 1911, Mary received an honorary degree from Brown University for her admirable work in the fields of art and education. She was also honored by the French government as an officer of the French Academy. Nine years later, Mary had an unfortunate accident when she fell on one of the icy streets in Providence. As complications arose, any chance for recovery appeared remote. A short time later on March 10, she died. Her death did not go unnoticed. Besides the *Providence Journal*, both the *New York Times* and the *New York Herald* noted her passing. Mary had lived to the age of seventy-three. Her remains were interred in the family plot on Author's Ridge in Sleep Hollow Cemetery

in Concord next to the same prominent neighbors she grew to admire. Mary's will stipulated that upon her death, the school would be placed in the hands of the school trustees with the proviso that they continue to maintain Wheeler's rigorous and diversified educational curriculum.

The Mary C. Wheeler School recently celebrated its 125th anniversary as an independent-learning facility that serves children from nursery school through secondary education. Today, Wheeler's enrollment exceeds eight hundred students with a full and part-time faculty of about two hundred. The school has been hailed for its experimental learning programs (during the school year and in the summer), community involvement initiatives and environmental awareness. The school even has its own radio station operated by its students: WELH-FM.

In the end, Mary's choice of campus is a testament to her leadership and forward thinking as it is in proximity to prestigious Brown University and Rhode Island School of Design.

OUT OF NECESSITY

To be a graduate of the Katharine Gibbs Secretarial School meant something special throughout most of the twentieth century. There was no better reference for young women seeking employment in the business world than possessing a Gibbs diploma. Graduates of the business school were not only known for their skills and deportment but also easily identified by the white gloves and hats they wore when going to and from work. But the school might never have come into existence were it not for an unfortunate turn of events in the life of its founder, Katharine Gibbs.

Katharine Gibbs did not start out with the intention of founding one of the most famous and reputable secretarial schools in the country. In fact, it was probably the furthest thing from her mind until out of necessity, following the death of her husband, she opened a school in Providence.

Katharine was born at the height of the Civil War (1863) in Galena, Illinois. (Ulysses S. Grant also hailed from Galena, where he worked in his father's general store prior to the start of the conflict.) As a young girl, Katherine was sent by her father, a wealthy meatpacking merchant, to live with her two spinster aunts in New England to acquire a more "cultural education." In 1882, she graduated from the Convent of the Sacred Heart in Manhattanville, New York. Fourteen years later, she married William Gibbs and settled with him

in Rhode Island. William was an adventurous sort and enjoyed sailing, which led him to becoming vice-admiral of the Edgewood Yacht Club. In 1909, he tragically fell to his death after slipping off the mast on his boat. Katharine, now a forty-six-year-old widow with two young sons to support and no source of income, was in desperate need of a job. She tried several ventures, none of which provided sufficient income. Finally, she borrowed $1,000 and purchased the Providence School for Secretaries in 1911. With the help of her sister, Mary Ryan, the school opened for business with a single student, Marshall H. Shelden—a man, no less. But soon thereafter, the school became exclusively for

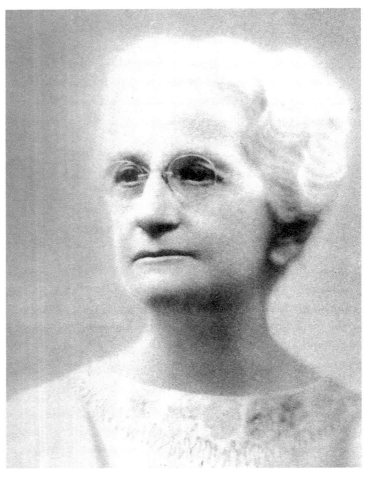

An image of Katherine Gibbs taken from a 1945 school course catalogue. *Author's collection (FLG).*

young women. The published purpose of the school was "to provide women of good education with the necessary training for representative secretarial positions in business, professional and offices."

Over the years, the school prospered, and before long, a second school was opened in 1917 in Boston (Boston School for Secretaries). The following year, a third school opened in New York City (New York School for Secretaries). By 1920, all the schools were renamed Katharine Gibbs School for Secretaries and Executive Training for Women. Although the Boston and New York City schools opened in the midst of the First World War, they would not be the last

Secretarial students posing underneath a portrait of the school's founder, Katherine Gibbs. *Author's collection (FLG).*

Gibbs schools to function during wartime. Katharine Gibbs remained the active head of the school throughout the Roaring Twenties and into the Depression of the 1930s. She died in New York City on May 9, 1934, of pneumonia following a short illness. She was seventy-one. Her funeral was held two days later in St. Patrick's Cathedral. Upon her passing, the school's leadership fell to her youngest son, James Gordon Gibbs.

Two years following the death of Katharine, the school celebrated its Silver Jubilee with a reception and dance at the prestigious Providence Biltmore Hotel. The school continued to grow under James's leadership as he proved himself an extremely capable administrator. Another school was opened in Chicago in 1943 during the height of the Second World War. A school catalogue published in 1945 noted, "It was more than a coincidence that the Katharine Gibbs School was prompted to extend its field of usefulness at such critical times," adding that "ambitious young women everywhere were eager to get the best possible training as demonstrated in times of peace for the serious war work that challenged them." In reality, during wartime, women were needed to fill the vacancies left by men going off to war. The catalogue also noted, "Conspicuous progress has marked the years— enlarged quarters and modernized facilities for the greater convenience of students, noteworthy additions to the faculty, improved curricula, better teaching methods." The message concluded by touting the school's guiding principles: "But the spirit and ideals and high purpose of Mrs. Katharine Gibbs are a worthy heritage that remains unchanged."

The school remained in the Gibbs family until James, wishing to retire, sold it to Macmillian, Inc., in 1968. It is interesting to note that James married his secretary, Blanche, who happened to be a Gibbs School graduate. After James's retirement, Blanche took over the leadership of the school and continued to do so until 1970, when she retired. Under Macmillian's ownership, the school maintained a strong reputation but eventually was forced to change its curriculum to meet the needs of modern businesses. No longer able to compete as an exclusive secretarial school, it added other programs of study, but that was not the only change. It became coed. There would also be numerous changes in ownership during the following decades.

In 1997, the Career Education Corporation (CEC) acquired the Gibbs Group. Two years later, the school was renamed Gibbs College. In 2006, after a failed attempt to find a buyer, Gibbs College, now located at numerous locations across the country, began the process of shutting its doors. In 2011, a century after its founding, the last of the remaining Gibbs College schools were permanently closed.

ENTERPRISING WOMEN

The story of Gertrude I. Johnson and Mary T. Wales is truly an American success story. Given the times in which they lived and the difficulty women faced in any professional endeavor in the early twentieth century, their story is nothing short of remarkable. Back in 1914, Gertrude and Mary founded a business school in Providence with just one student and one typewriter. Today, that school is a major university with multiple campuses in the United States and an enrollment of over seventeen thousand students. Although Gertrude and Mary were not responsible for the school's significant growth over the last half century or more, it was nevertheless their vision and perseverance that has made the university what it is today.

Our story begins when the young ladies were both students at the Pennsylvania State Normal School in Millersville, Pennsylvania. Here they commenced a friendship that would be rekindled in Providence. It became a friendship that lasted a lifetime. After graduating in 1893, Mary spent five years teaching in Pennsylvania before moving to Massachusetts. She taught school there for another twelve years before taking some time off and moving to Rhode Island in 1911. Gertrude graduated in 1895 and continued on with her education, receiving a master's degree in 1897. After teaching for a while in public schools, Gertrude took a position in a bank, where she acquired a firm understanding of the business practices of the commercial world—an understanding that proved extremely useful to her. Five years later, she decided to return to the profession in which she was originally trained and accepted a teaching position at Bryant and Stratton business school in Providence. Soon, Mary was also teaching at the same institution. The old college friendship between Gertrude and Mary was renewed.

After only a few years at Bryant and Stratton and with the world on the brink of war, the two friends—both nearing forty years of age—threw caution to the wind and opened their own business school. The school opened in September 1914 in Gertrude's home on Hope Street in Providence. Soon, the school attracted enough students to warrant a move to larger quarters on Olney Street. Here it remained until the decision was made to relocate in downtown Providence at 36 Exchange Street, sometime after the close of World War I. With an influx of returning GIs after the war, the school prospered. Mary focused on teaching, while Gertrude applied her acquired skills from her banking days to run the administration of the school. The school's curriculum included the usual business studies of the day: typing, shorthand and bookkeeping, as well as English and mathematics. New technology of the day provided students the opportunity to use

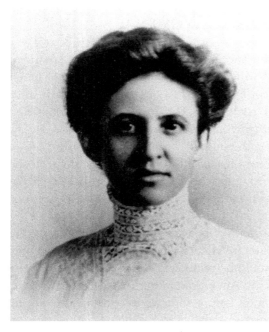

typewriters, bookkeeping and mimeographing machines and adding machines then called "comptometers." In the early part of the twentieth century, office jobs, including secretarial positions, were dominated by men. But soon, such employment came to be socially acceptable for women as well as men. Capitalizing on the change, Johnson & Wales Business School had students of both genders attending classes.

The school continued to prosper under their capable leadership, awarding diplomas to numerous students in the decades to follow. In the meantime, the school had developed an excellent reputation for turning out well-qualified graduates to work in the business community, along with an outstanding record for job placement. Early on, it became evident that these founding mothers truly cared about their students. Under their leadership, the

Top: Gertrude I. Johnson. *Courtesy of Johnson & Wales University.*

Left: Mary T. Wales. *Courtesy of Johnson & Wales University.*

A 1930s postcard image of Johnson & Wales Business School at Exchange Place, Providence, Rhode Island. The school is the five-story building at right center. *Author's collection (RJD).*

institution survived two world wars, the Great Depression and the great hurricane of 1938 that flooded their building on Exchange Street.

Following World War II, the future of the school looked even brighter as more women were entering the workforce and needed the proper business training to succeed. But there was a dilemma: the two women were now advancing in age, and worse, Mary was battling cancer. After carefully assessing the situation, both women decided that it was time to find a buyer for the school that they had loved and sacrificed so much for over thirty years. In June 1947, Gertrude and Mary sold the school to a former student's husband and his business partner. Vilma Gatta was not only a graduate of the business school but also worked there, teaching classes while serving as a jack-of-all-trades. Over the previous several years, Vilma had developed a strong bond with both of the founders, and as spinsters, Gertrude and Mary took a liking to the young woman, whom they treated as a daughter. After the sale, Gertrude and Mary were free to retire to their Warwick home. But in 1952, Mary died from her illness. Soon thereafter, Gertrude moved back to Pennsylvania, dying there in 1961.

The story of Johnson & Wales continues onward. At this writing, the school celebrates its centenary as an institution of higher learning. The small business school that Gertrude and Mary sold in 1947 has truly prospered. Under the highly capable leadership of the new owners, Edward Triangelo

(Vilma's husband) and Morris Gaebe, the school has blossomed. Within five years of the two assuming ownership, the school doubled in size. In 1960, the school became an accredited junior college, and in 1963, Johnson & Wales, under state charter, became a nonprofit institution. There were additional major milestones. In 1970, the school became a four-year college, and in 1988, it became a university. Today, the school is nationally known for its hospitality programs and is internationally recognized for its School of Culinary Arts.

Gertrude and Mary would be proud of how their small school has evolved and what it has accomplished over the past century. Their names will continue to live on at Johnson & Wales University.

Chapter 6
RELIGIOUS LEADERS

I think you have every right to cherry-pick when it comes to moving your spirit and finding peace in God. You take whatever works from wherever you can find it, and you keep moving toward the light.
—*Elizabeth Gilbert,* Eat, Pray, Love, *2006*

A QUAKER MARTYR

Most elementary school children know that the Pilgrims came to the New World from England to avoid religious persecution. The Pilgrims had left their native land as dissenters of the Church of England and what they felt were its corrupt practices. The largest majority of the colonists were called Puritans. By simple definition, Puritans were English Protestant extremists who felt that the Church of England had become a product of its own political struggles and man-made doctrines. Further, they believed that the church had not gone far enough during the reformation movement. A person unfamiliar with their plight might think that Puritans would be tolerant of believers from other religious faiths, having gone through a similar experience themselves. Ironically, it was quite the opposite. Puritans were steadfast in upholding their own religious views and always at the expense of other religious denominations. Perhaps surprising to many, Puritans were extremely intolerant and cruel enforcers of their own doctrine—God help those who thought otherwise. Their main target in the seventeenth century happened to be Quakers.

In the Massachusetts Bay Colony, Quakers were considered "dangerous subversives" and, therefore, treated with contempt. Worse, Quakers were subject to severe punishment, banishment and even death if they continued to practice opposing religious views. In 1661, when King Charles II was informed about the subjugation, he ordered the immediate release of all Quakers imprisoned solely because of their religious beliefs. His action resolved the more harsh punishment, but unrestrained humiliation and public beatings continued. Unfortunately for Mary Dyer, it was too late. This is her story.

Mary Dyer was born in England and came to the colonies after a ten-week ocean voyage in 1635 for the same reasons others did: religious freedom. Mary was five months pregnant at the time. She and her husband settled in Massachusetts. Because of the religious oppression there, she and William followed the teachings of a freethinker they had befriended, Ann Hutchinson. Together they departed for Rhode Island, where the Dyers eventually settled in Newport. The Dyers' departure from Massachusetts was hastened even more so when Mary was called "the mother of a monster." Unfortunately for the Dyers, their baby daughter was born seriously deformed. The stillborn infant was buried clandestinely on advice from others. When the facts finally surfaced about the birth, the corpse was exhumed and examined. The deformity of the corpse was confirmed, and the floodgates opened for all to see and hear. Medically naïve and exceedingly superstitious as people were at the time, Mary and her husband were looked on as evil for producing such a hideous offspring. As Ruth Plimpton noted in her biography, "October 17, 1637, was a day that Mary Dyer was not allowed to forget."

The Dyers lived in Newport for several years. There they produced six children and all healthy. Then for reasons unclear, the family returned to England for a five-year hiatus. While there, Mary became a Quaker. On the return trip that channeled through Boston, Mary began preaching her new faith. As expected, she was promptly imprisoned. Though her release was eventually secured by her husband, it was predicated on a promise that she would not speak to anyone until she crossed the border into neighboring Rhode Island. Mary complied, but two years later, she returned Boston to visit several imprisoned Quakers. She was arrested and put in jail once again. Mary was eventually released, but not before being warned that if she returned, she would be hanged. The warning fell on deaf ears. Within weeks, she was back in Boston and arrested again. Her trial was short; she was convicted and sentenced to death by hanging.

An artist's rendition of how Mary Dyer may have looked while being lead to her hanging. *Courtesy of the Library of Congress.*

The hanging was to take place on Boston Commons. When Mary was marched from the jail to the gallows, the instrument of death was already in place: a long knotted rope swung over a large elm tree. Before being led up the stairs, she was forced to watch the execution of some of her companions (history does not record her reaction). Then it was Mary's turn. Slowly, she was led up the stairs to the platform and made to stand on the trapdoor. Next, the executioner bound her arms and secured her skirt by tying rope around her ankles. Lastly, the hangman tied a handkerchief around her head to cover her eyes. Then the unexpected happened. She was granted a reprieve but at a price: that she would never again return to Massachusetts. After her release, she departed for Rhode Island.

Only a few months later, Mary did the unthinkable: she returned to Boston. Again she was arrested and sentenced to death. On June 1, 1660, while on the gallows, she was given the opportunity to save herself. She refused. The signal was given, the trapdoor fell open, Mary dropped hard and her neck snapped. A soldier in attendance was the first to speak: "She hangs like a flag." Then a dissenting voice from the crowd responded: "She

A detail image of a cart-and-tail whipping. *Archives photo.*

hangs like a flag for others to take example from." Mary freely went to her death not only as a martyr for Quakerism but, in a larger sense, also for religious freedom for all. Her body was removed and buried in an unmarked grave on the nearby grounds.

After witnessing the tragic event, Edward Wanton, a soldier, vomited several times. When he arrived home at his mother's house later that day, he threw down his sword and cried on his mother's shoulder, saying, "We have been murdering the Lord's people." He vowed never to wear the sword again. Edward was true to his word and soon after became a devout Quaker.

Although Mary was the last to die in such a fashion, religious persecution continued in the Massachusetts Bay Colony for over a decade. A statute called the Cart and Tail Law was passed by the Puritans to circumvent the king's edict. The law dictated that any person "of a certain description" caught in Boston "was to be stripped to the waist, fastened to the back of a horse drawn cart and whipped." The severe punishment was inflicted while the unfortunate was dragged behind the cart. The "certain description" referenced in the law was meant specifically for Quakers. The whipping continued until 1677, though the death penalty was not formally repealed until six years later.

THE PUBLICK UNIVERSAL FRIEND

Jemima Wilkinson, or more correctly, the Publick Universal Friend, was the first woman born in America to establish a religious sect. While this alone may sound impressive, she did this, as she believed, after her own death and resurrection. She was less than twenty-five years old at the time.

Jemima was born on her father's farm on November 29, 1752, in Cumberland, then a rural town. Her father, Jeremiah, was a Quaker of old Rhode Island stock and a cousin to Stephen Hopkins, governor and signer of the Declaration of Independence. Little is known of her mother, Amey Whipple. She may not have been a practicing Quaker, dying when Jemima was quite young. Jemima was the eighth of twelve children born into the family. A devout Quaker, Jemima spent much of her spare time studying the Bible. When the country was swept up in the religious fervor of the Great Awakening, it came as no surprise that Jemima, too, was caught up in the religious zeal. Jemima began to favor a local Baptist group known as the New Lights, so-called for their passionate or emotional form of worship as compared to the more sedate methods of the established church sometimes referred to as the Old Lights. Her affiliation with this group soon led to her expulsion from the Quaker congregation.

On October 4, 1776, Jemima took sick with fever and was confined to bed. After several days of illness, she claimed to have died. When awakened from death, she was no longer Jemima Wilkinson but the Publick Universal Friend. Though she never claimed to be the Messiah or the second coming of Christ, Jemima began to preach before all who would listen. It is interesting to note that another woman, English-born Ann Lee, a contemporary of Jemima, went on to establish the United Society of Believers in Christ's Second Appearing, more commonly known as the Shakers.

Jemima was a persuasive public speaker, something unheard of for a woman of her calling in eighteenth-century America. Over the next six years, she traveled extensively in Rhode Island and neighboring Massachusetts and Connecticut. She preached to American Revolutionary War soldiers encamped near Aquidneck Island, positioned there to discourage any advance by British troops then occupying Newport. It was said that she even consoled American prisoners who were condemned to death for spying or desertion.

As the word of Jemima's ministry spread across the area, many came to hear her preach. She traveled constantly, but her home soon shifted from Cumberland to Little Rest, a village in South

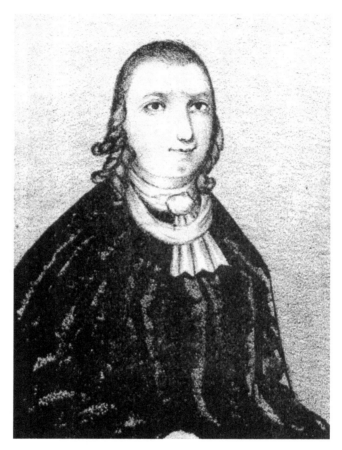

An image of Jemima Wilkinson. *Courtesy of the Providence Public Library.*

Kingstown. There she resided at the home of Judge William Potter. For nearly nine years, Jemima used the Potter residence to expand her ministry. Judge Potter was so impressed by her teachings that he and his family became some of her converts. Showing his absolute commitment, he built a fourteen-room addition to his house for Jemima's exclusive use. Jemima's followers in nearby East Greenwich were so taken by her ministry that they built a meetinghouse on a one-acre lot from money donated by one of the believers.

Spreading from its base in South Kingston, Rhode Island, the Universal Friend's ministry took hold in southern New England, first with converts in the New London, Connecticut, though it soon spread to New Milford in

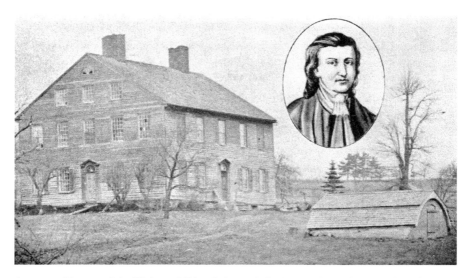

A postcard image of the Universal Friend's home in Jerusalem, Yates County, New York. *Author's collection (RJD).*

the western part of that state. So successful was Jemima's ministry that the converts of New Milford built her a meetinghouse. Next to South Kingstown, the New Milford congregation became the largest in New England. By 1787, with more than two hundred active followers across New England, Jemima turned to Pennsylvania for more converts. Her sojourn in the Keystone State lasted slightly more than a year. While staying near Philadelphia, she met with mild resistance. The citizens' attitudes were understandable. Philadelphia—a colony founded by eminent Quaker William Penn and now the largest city in North America—was heavily populated by Quakers. Quite simply, they did not take kindly to religious interlopers. Opposition to Jemima's preaching can be attributed to two causes. First, and most obvious, the Quakers were not appreciative of a spin-off and rival church such as the Universal Friend Church. Second, and perhaps more importantly, the unorthodox notion of a female preacher speaking in public offended many. Yet despite the opposition, Jemima's preaching in Pennsylvania and nearby New Jersey nevertheless proved quite successful.

By late 1788, the Publick Universal Friend was ready to depart Pennsylvania and return to New England but only temporarily. During the previous year, plans had been drawn up to move all of the faithful to a new settlement at Seneca Lake in upstate western New York. Some of the sect decided to travel to the site in advance of Jemima. Upon arrival, they acquired suitable land for farming and started to construct dwellings. Jemima did not arrive at

the new settlement until April 1790. By 1794, the community moved for the last time to another township in New York that they called Jerusalem. Here, she and her followers would live until her death.

Jemima, the Publick Universal Friend, passed away in late 1819. Although a book published two years after Jemima's death attempted to discredit her ministry by claiming her faith healings were a hoax and her motives insincere, none of these claims were ever substantiated. Despite her sect dispersing less than a generation following her death, her impact on religious life in the Northeast during the early years of the new Republic proved meaningful.

Chapter 7
MAKING THEIR VOICES HEARD

Race prejudice is not only a shadow over the colored—it is a shadow over all of us,
and the shadow is darkest over those who feel it least and allow its evil effects to go on.
—Pearl S. Buck, What America Means to Me, *1943*

FROM INDENTURED SERVANT TO ENTREPRENEUR

Most of what is known about the well-liked and hardworking woman from Providence was published in two obscure biographical books of the late 1830s and early 1840s: *Memoirs of Elleanor Eldridge* and *Elleanor's Second Book*. Both books, along with a few legal documents and some brief narratives, many repetitive in nature, provide the only remaining evidence historians can rely on in defining Elleanor Eldridge's life and accompanying misfortunes. But the terse glimpse is more revealing than one can imagine. The biographies, court papers and scant anecdotes offer a harbinger of racial injustices perpetuated on Elleanor during her lifetime. The fallout would continue to resonate long after her death. Though Elleanor was far from alone in suffering the evils of racial discrimination during the early to mid-nineteenth century, her troubles appear somewhat unique in view of her status in the community. After learning about her life, many have found Elleanor's story far less heartbreaking and more thought-provoking than first imagined. As ghostwriter and friend Frances Harriet Whipple said

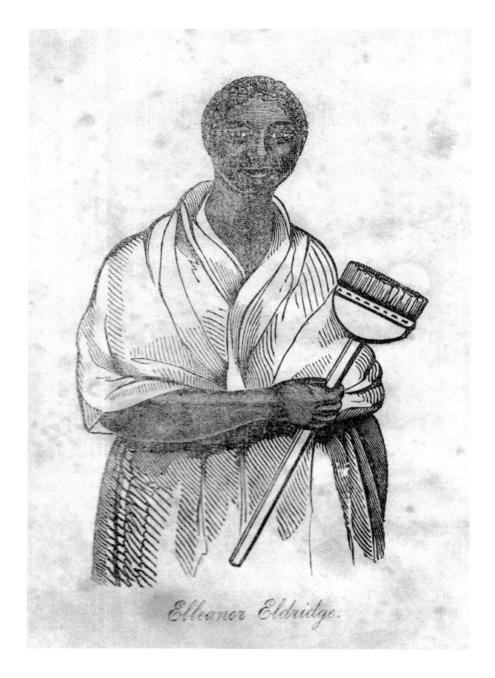

An artist's depiction of Elleanor Eldridge. *From* Elleanor Eldridge. *Author's collection (RJD)*.

in the preface of Elleanor's initial memoir, she was "an unoffending citizen" who was "robbed of her rights, even though she be a woman—and a *colored woman*" at that. In the end, Elleanor's story proves to be deeply inspirational because of her unfailing perseverance and steadfast desire to succeed.

Born in Warwick, Rhode Island, on March 26, 1785, Elleanor could trace her paternal routes back to the Congo, from where her grandfather, his wife and four children were taken as slaves to America. Robin, a son (later to become Elleanor's father), grew up to fight in the American Revolution. Because of his service, he was granted his freedom. Unfortunately for Elleanor, her mother, Hannah Prophet, died when she was only ten.

To make ends meet, Elleanor became an indentured servant, first working for twenty-five cents per week only to be reemployed for several more years by the same family for two shillings per week. By the time she turned nineteen, her father had died, and she was left to provide for herself. Elleanor's first job was driving cows to pasture, feeding and milking them and taking care of the chickens. She also performed other menial tasks while working on the family's estate before learning how to spin yarn and weave fabric. Later, she painted houses—whitewashing, as it was called—and became quite adept at the profession. As another venture with her sister, they boiled soap and sold it in the Providence marketplace.

During the following years, Elleanor denied herself nearly every comfort except the bare necessities of life. Through thirty years of hard work and frugality, she was able to purchase a home in Providence without having to take a bank loan—a rarity for a female at the time, never mind a black woman. Later, she expanded the building and took on a tenant, the success of which led her to invest in additional real estate. When two nearby lots became available, she purchased them. Elleanor built houses on the property and leased them to additional tenants. Then the roof collapsed—figuratively, not literally.

To finance the above purchase, Elleanor secured a loan from a Mr. Greenold of Warwick. Putting $500 as a down payment to the owner, she took a $1,500 loan with Mr. Greenold under the condition that she would pay an interest rate of 10 percent "and renew the note annually." The term of the loan was for four years. Then she was stricken for a second time in her life with typhoid fever. To recuperate, Eleanor decided to visit friends in Adams, Massachusetts, leaving her affairs in the hands of her brother. But after a few weeks, rumors began to swirl in Providence that evidently reached Warwick that Elleanor had died from her illness. Contrary to the rumors, her condition did improve after a lengthy recuperation. When she recovered

enough to travel, she returned home but not before frightening the wits out of a young baker's son when she first stopped for bread. Having known Elleanor in the past, having heard the rumors of her untimely demise and now seeing her in the flesh, he blurted out, "Don't come any nearer!...don't Ellen, if you be Ellen...cause...I don't like dead folks!" After convincing the boy that she was very much alive, she ate the bread and returned home, where she was greeted by a shocked but exuberant brother. Not wanting to disturb her with unsettling news about her property, he waited until the morning to do so.

The following morning, Elleanor was told that the mortgage holder had died and his business affairs were now handled by a surviving heir. Not knowing her whereabouts at the time, the heir requested that the sheriff attach the property for nonpayment of debt. Why Elleanor's brother never interceded is unknown.

Elleanor immediately set out for the heir's home. After pleading her case, he promised not to pursue her for the entire amount, provided that she continued to make interest payments. Not long after, and in spite of his promise, he sold the property while she was thirty miles away nursing a friend's daughter with cholera. As Frances Whipple relates in her memoir, "She [Elleanor] confided in the promise of one who had more regard for the purse than for his honor or his Christian character."

In January 1837, Elleanor's case to regain ownership of her lost property on grounds that the auction was never advertised as required by law was brought before the Court of Common Pleas. Though the sheriff was contradicted by several witnesses who never saw the posts, their testimony was discounted because the "oaths of common men could not be taken against that of the High Sheriff." The judge ruled in favor of the sheriff.

Not to be defeated, Elleanor hired two investigators to look into the matter. Neither man could find any evidence to substantiate the sheriff's claim that the impending auction was properly advertised. A day before the case was to go to appeal, the purchaser of the property came forward and told Elleanor's attorney that he would restore the property for $2,100 and two years of rent. Elleanor agreed and withdrew her appeal. After raising the funds, she was rebuked by the owner, who demanded an additional $200 because she purportedly took too long in making the payment. When she raised the addition sum, she was again rebuked; this time, he requested $2,500 and six months of rent. Amazingly, Elleanor was able to raise the additional money, and this time, the owner agreed to sell the property back to her.

As biographer Frances Whipple explained, "No man ever would have been treated so; and if a white woman had been the subject of such wrongs, the whole town—nay, the whole country, would have been indignant." As a social and political activist, Frances drafted the biographies referenced above as a moral crusade to right the wrongs perpetuated on Elleanor. But more so, both books were published to raise money to pay for Elleanor's legal fees and to defray expenses incurred while attempting to regain her property. By all accounts, Elleanor survived the financial shenanigans and discriminatory practices of the mortgage holder and lived to be proclaimed, at least by one source, "the richest African-American woman in America."

Little else is known about the remainder of Elleanor's life. The actual date of Elleanor's death is clouded. Most historians accept 1865 as the most probable year of her passing. But what has been documented is a powerful testament to a woman's perseverance under extreme hardships to circumvent discriminatory business practices that became an appalling blueprint for far too many years.

A Hair Doctress and Abolitionist

Born Christiana Babcock in South County, Rhode Island, somewhere around 1820, details concerning Christiana's early life are sketchy at best. The fact that her adolescence went undocumented is not unusual for a woman of mixed blood who apparently descended from slaves who worked the plantations in South County and Native Americans who roamed the countryside during the seventeenth century. The little that is known about her youth has been pieced together from census records and court documents. What is known is that she was one of nine children of Mary and Charles Babcock and that in her family tree were Revolutionary War heroes. Christiana's upbringing was probably little different from all the others who were born with a similar heritage and brought up in a small community in the backwoods of Rhode Island. No doubt, Christiana and those like her yearned for greater opportunity and adventure.

One of the first recorded incidents about Christiana's life was her leaving for Boston to become a hairdresser, or as the trade was called then, "hair doctress." Her styles became an instant sensation, and soon she was catering to Boston's most influential ladies. At the time, she met a clothes dealer by

the name of Desiline Carteaux. They eventually married, but for reasons unknown, the union ended in divorce.

It was while living in Boston that Christiana met a gentleman named Edward Mitchell Bannister whom she soon employed as a barber in her establishment. Though he worked as a barber, Bannister was a Canadian-born artist; cutting hair was nothing more than a means to make ends meet.

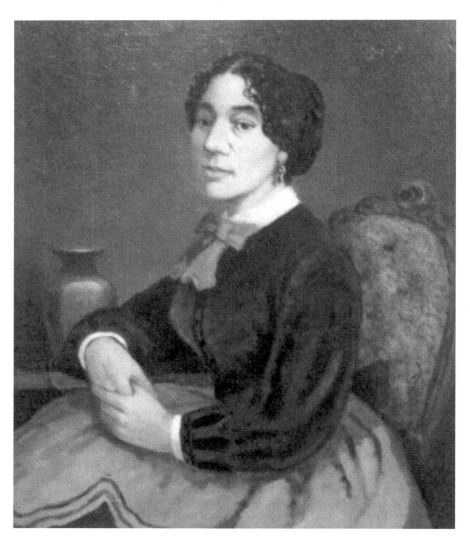

A painting by Edward Mitchell Bannister of his wife, Christiana Babcock Bannister. *Courtesy of the Rhode Island Black Heritage Society (RIBHS). Photographed by the author (FLG). The painting from the RIBHS is on loan to the Rhode Island School of Design Museum.*

Both fell in love, and soon they were married. Over the years, Christiana had managed to save a good portion of her earnings. With Christiana's financial backing, Edward was able to concentrate more on his artistic work and organize exhibitions that quickly propelled him into the limelight. Thanks to Christiana, Mitchell eventually became one of the most successful black artists in America.

During the Civil War, the Bannisters lived with a black activist named Lewis Hayden. Hayden became famous for helping fugitive slaves escape via the Underground Railroad. It was probably while witnessing Hayden's work and that of other abolitionists of the era that moved Christiana to help raise funds to aid the Fifty-fourth Massachusetts Infantry Regiment, a contingent of all-black enlistees. Perhaps her greatest thrill came when she and Frederick Douglass were afforded the honor of presenting the colors to the Fifty-fourth prior to the regiment's departure for the battlefield. As the war labored on, she did not forget them. On several occasions, she led the fight to secure equal pay and benefits for black enlistees of the regiment.

In 1869, with racial tensions running high in Boston, Christiana and her husband moved to Providence, where she opened a number of successful hair salons throughout the city, still maintaining an establishment in Boston into the 1880s. After living as a disciple among several noteworthy abolitionists, activism was now in her blood. One of her greatest accomplishments was the establishment of the Home for Aged and Colored Women in Providence that was also made possible by the financial support of Christiana's friends and salon clientele. Still in existence, the home is now known as the Bannister Nursing Care Center. The contemporary facility prides itself on providing the highest degree of extended-stay nursing care for those seniors facing various levels of disabilities.

During the last decade of his life, Edward Bannister's popularity and fortunes declined. He died in 1901 after a sudden heart attack. Christiana passed away a year later in the rest home she helped establish. Sadly, and for reasons unknown, her name does not appear on the headstone at Providence's North Burial Ground where she and her husband are interred. But wait—her death did not go unrecognized, even if it took a century to do so. In 2002, a bronze bust of Christiana was dedicated at the statehouse in Providence in her honor. The recognition was not only well deserved but also long overdue.

BORN TOO SOON

Matilda Sissieretta Joyner (Jones), the "Black Patti," as she was called professionally as a singer, was tagged with the unique moniker in tribute to her white counterpart, soprano Adelina Patti from Italy. Both ladies were exceptional opera singers with clarity and richness of voice that was unsurpassed by other performers of the period. Each achieved worldwide stardom while raking in huge sums of money and countless awards during her years as an individual performer. When Matilda was born in Portsmouth, Virginia, on January 5, 1869, Adelina was well into her twenties. Whether Matilda and Adelina ever met remains unclear, but it is known that each had an unbridled respect for the other's talent.

Matilda's father, Jeremiah Malachi Joyner, was a Baptist minister. Her mother, Henrietta Beale, was said to be a gifted soprano. At the age of seven, Matilda—or "Sissie," as she was affectionately nicknamed—moved with her family to Providence. Soon, her talents were recognized after singing at the Pond Street Baptist Church. With parental support and encouragement, she enrolled at the Providence Academy of Music while only fourteen. At this tender age, she met and married David Richard Jones, whose dual professions were news dealer and bellman at a local hotel. He was also a well-known gambler.

As word spread about Matilda's radiant voice, she was invited in 1887 to perform in front of a crowd of five thousand at Boston's famed Music Hall. She was only nineteen years old. The following year, Matilda made her New York City debut performing at Steinway Hall. While in the city, she was noticed by Adelina Patti's manager, who arranged for Matilda to become part of the Fisk Jubilee Singers, a group that eventually toured the West Indies and other Caribbean nations. The successful tour brought her much notoriety that eventually contributed to her successful performances in front of four consecutive presidents (Harrison, Cleveland, McKinley and Roosevelt). What made her even more in demand by the general public was her varied repertoire of music—grand opera, light opera and popular music.

While singing with the Grand Negro Jubilee in 1892, Matilda performed in front of an estimated crowd of seventy-five thousand at Madison Square Garden in New York City. There she received rave reviews for her superb performances. And in June of the same year, she became the first African American to sing at the New York City Music Hall (today known as Carnegie Hall). Her rising fame was accompanied with invitations to sing at the Pittsburgh Exposition and the World's Columbian Exposition.

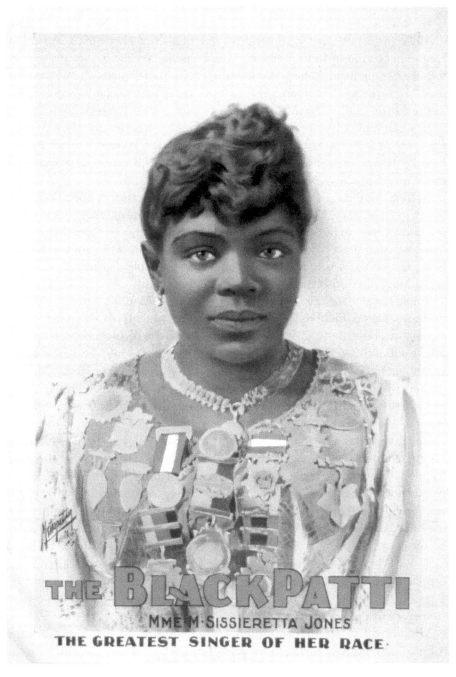

Matilda Sissieretta Joyner as she appeared during her heyday as a celebrated soprano.
Courtesy of the Library of Congress.

By now, Matilda could claim performances not only in America and the Caribbean to her already illustrious credentials but also Africa, Australia, England, Germany, India, Italy, Paris and Russia. Yet racism always seemed to raise its ugly head. When Matilda did receive testimonials, the words were usually guarded. There were some exceptions. After a brilliant performance at the Music Hall in New York City, a newspaper critic probably went out on a weak limb when he said: "If Mme. Jones is not the equal of Adelina Patti, she at least can come nearer it than anything the American public has heard." It was high praise indeed and perhaps a bit risky considering the racial mood of the country.

In 1896, Matilda's mother became ill. She decided to return home to Wheaton Street in Providence. Having to earn a living while acting as a nursemaid could not have been easy, but she managed to survive for nearly two more decades. To make a living, she formed the Black Patti Troubadours. The profits made life easier but were nowhere near what she had earned while touring cross-country and around the world during the peak of her popularity.

Things begin to darken as the years progressed. In 1900, Matilda and her husband, David, divorced. They had one child, Mabel, who died before the age of two. Historians have not said what caused the divorce, though records might still exist to denote the reason. A fair guess would be that David's gambling habit had something to do with the failed marriage. Making matters worse, because of her race, Matilda was forbidden to perform at the Metropolitan Opera House in New York City (the racial barrier was finally lifted in 1955 for singer Marian Anderson).

In 1915, Matilda retired from professional singing to care, almost exclusively, for her invalid mother. With what little spare time she had, Matilda devoted herself to church activities, such as helping the homeless and giving singing lessons to children. As her savings continued to dwindle, she was forced to sell much of her property. Unfortunately, few came to her aid, the only exception being William Freeman, a real estate agent and president of the local chapter of the National Association for the Advancement of Colored People (NAACP). He paid Matilda's taxes and water bill and also supplied her with fuel for cooking and staying warm. When she died on June 24, 1933, Matilda was destitute. Her remains now lie in Grace Church Cemetery in Providence.

Matilda still has an enthusiastic following. Long after her death, an admiring tribute was paid by a caring individual. The sentiment was published on the website Find-A-Grave and is worth repeating. After punctuation corrections, it reads:

Dear Miss "Sissie,"

Happy belated birthday. I'm sorry to say, you were born too soon; deserved more respect!! But me, and no doubt many others, are thankful to be able to hear/have heard your beautiful instrument, your professional and angel-like voice. May you always be remembered.

Love from the Netherlands,
Bianca

ATHLETES

I think sports gave me the first place where this awkward girl could feel comfortable in my own skin. I think that's true for a lot of women; sports gives you a part of your life where you can work at something and you look in the mirror and you like that person.
—*Teri McKeever, head coach of the 2012 U.S. Olympic swimming team*

RISING TO THE CHALLENGE

How many readers think that in their eighties, they would have the desire—never mind physical strength and stamina—to climb a mountain? Well, Annie Smith Peck not only thought about it, but she also actually accomplished the grueling feat at the age of eighty-two when she climbed Mount Madison in New Hampshire. Yet as Dr. Russell A. Potter points out in his brief article about her, titled "Scholar and Mountaineer," "[Annie] is one of the most notable women in the history of Rhode Island [yet] it's a tragedy that so few people know of her life and accomplishments." In terms of her athletic prowess and perilous adventures, he may be right. See if you agree.

Annie Smith Peck came from a well-to-do family in Providence. Born on October 19, 1850, she was the youngest of five children. Her father, a graduate of Brown University, had a successful law practice and was a member of the Providence City Council. Annie's collegiate education took

her from Rhode Island College (known at the time as the Rhode Island Normal School) to the University of Michigan, where she received both a bachelor's and master's degree in Greek and classical languages. She then went on to become a professor of Latin and elocution at Purdue University, where she excelled as one of only a handful of women to hold such an illustrious position in the 1880s. After leaving Purdue, she studied in Europe for two years before returning to the United States to become a professor at Smith College. She resigned that position in 1892 to pursue more lucrative opportunities on the lecture circuit.

Teaching and lecturing, however, only whet her appetite for bigger and more difficult challenges. At the advanced age of forty-four, Annie decided to climb mountains as a full-time pursuit, an activity she tried only on occasion in her thirties. For a woman living in the nineteenth century, this 180-degree career change from a professor to a thrill seeker seemed totally out of character, if not utterly ludicrous. But was it? Using Annie's own words, Dr. Potter explained her drive, writing, "I decided in my teens that I would do what one woman could do to show that women had as much brains as men and could do things as well if she gave them her undivided attention."

Mountain climbing was a relatively new sport when Annie made her first ascent. The possibility of death was always present with each ascending or descending step, as Annie was well aware. During the early days, there were few oxygen tanks with masks or other supportive equipment in conventional use. There was no denying that at high altitudes, it was near impossible to survive without them. Also, insulated outdoor clothing to retain body warmth and protect against frostbite was virtually nonexistent. In retrospect, it is astonishing to know that many of Annie's climbs were accomplished while wearing tunics and knickerbockers.

During her adventurous years as a mountain climber, Annie was credited with setting several records. In 1895, she became the first woman to ascend the Matterhorn in the Swiss Alps. The climb brought her minor celebrity status. Two years later, she set the women's altitude record at Mount Orizaba in Mexico. Then in 1908, at the age of fifty-eight, Annie set another record. After a third attempt at climbing Mount Huascaran in the Andes of Peru, she succeeded in reaching the 21,812-foot peak. As hazardous as the ascent was, the descent was noticeably worse because it was accomplished in the dark. The grades of descent were nearly insurmountable, anywhere from forty to sixty degrees. Annie later said, "My recollection of the descent is as of a horrible nightmare, though such I never experienced." As an afterthought, she added, "Several times I declared that we should never get down alive."

A studio photograph of Annie S. Peck attired in her climbing gear. *Courtesy of the Library of Congress.*

Mercifully, they did survive but not without sustaining severe injuries. All were badly frostbitten owing to the loss of some protective clothing by a careless guide and their own negligence losing mittens from their half-frozen hands. Shortly after the descent, a member of the party underwent surgery to have a finger, part of his hand and half a foot amputated in a Lima hospital. But, at least for Annie, there was some glory. The Peruvian

government presented her with a medal, and later, a mountain peak was named in her honor: Cumbre Ana Peck.

Though not record-setting, in 1911, Annie climbed Peru's Mount Coropuna. On the ascent, she raised a "Votes for Women" pennant showing her support for women's voting rights. That's right. Annie was also an activist for women's issues.

If the above wasn't enough, Annie took on other challenges, though not nearly as demanding as her climbs. While still lecturing about her remarkable life, Annie managed to write travel guides about South America. Her books about that subject sold quite well.

Annie's death-defying adventures finally came to an end when she died of bronchial pneumonia at her home in New York City on July 18, 1935. Her death was hastened after an exhaustive climb of the Acropolis in Athens, Greece, only weeks earlier. Annie was cremated, and her ashes are interred in the North Burial Ground in Providence.

THE QUEEN OF BASEBALL

Elizabeth "Lizzie" Murphy was not your typical woman. Born on April 13, 1894, and one of seven children, growing up, she preferred to play baseball with the boys rather than playing dollhouse with the girls. Years later, while reminiscing about her youth, she said, "I always loved boys' sports. They're so active, they wake you up."

Lizzie first played the game with her brothers. She was only allowed to play because she owned the baseball. In 1918, after years of perfecting her skill at the game, Lizzie was good enough to play semipro with the Providence Independents. There she was given the nickname "Spike." Two years later, she joined the Boston All-Stars, a team that consisted of former major-league players. She did this for seventeen years, many times playing over one hundred games a season. But her claim to fame came when she played at Fenway Park on August 14, 1922, in a benefit game between the Boston Red Sox and the Boston All-Stars. In 1929, she would go on to become the first woman to play on an all-black baseball team, the Cleveland Colored Giants.

According to the late Dick Reynolds of the *Providence Journal*, Lizzie possessed three attributes required of all good ballplayers: a good pair of hands, speed and intelligence. But in a feature article in *Sports Illustrated*, writer John Hanlon wrote that Lizzie's shortfall was a lack of power when at

Elizabeth "Lizzie" Murphy wearing a baseball uniform with her name embossed on the jersey. She also wore a jersey that displayed the name of her hometown. *Courtesy of the George Hail Free Library and the Warren Athletic Hall of Fame.*

bat (though not hitting for power, she still could claim a .300 lifetime batting average). Hanlon was probably right, but many felt that what Lizzie lacked in power, she made up for with her fielding and speed on the bases.

During regular season games, Lizzie usually wore a uniform with her full name embroidered on the front of the jersey. Why her name and not the team's name? Because fans were more interested in seeing her than the team she played for at the time. As for her long reddish-blond hair, she wrapped it in a bun and then tucked it neatly under her cap.

Not only did Lizzie make money playing the game (five dollars per game, along with a percentage of the gate), but also between innings, she sold postcards of herself in uniform and hawked them in the stands for a dime each. At a game held in Worcester, Massachusetts, she made twenty-two dollars, generally with only a crowd of one thousand in attendance.

Besides baseball, she was good at long-distance running, ice-skating and swimming. Outside of sports, she was also a talented violinist. Also in her repertoire was her ability to speak fluent French, a language that came in handy when she played in Canada. As John Hanlon tells it, "Lizzie overheard the opposition's first-base coach unsuspectingly giving the steal signal in French. Lizzie called time, set up a code with her catcher and flashed it each time a runner was to be sent down. 'Nailed five of them that way,' she said proudly."

To keep in shape while playing a man's game, Lizzie beat rugs and chopped wood. But eventually, her body gave out, and she knew it was time to hang up the cleats. She played her last game at the age of forty. After baseball, she married Walter Larivee, a mill supervisor. He died seven years later. Because her earnings from baseball fell short of carrying her into retirement, she worked in the mills of Warren. Later, she shellfished on commercial boats.

Like General William Tecumseh Sherman once said when proposed as a candidate for political office, "If drafted, I will not run; if nominated, I will not accept; if elected, I will not serve," Lizzie followed in his footsteps. When asked to attend testimonial dinners in her honor or baseball functions as a featured guest, she unceremoniously declined all invitations. As friends later surmised, "She never did go much for frivolities." Lizzie died in Warren at the age of seventy on July 27, 1964.

"THE FEMALE BOBBY JONES"

Ask any female golfer about the Vare Trophy, and it's likely that at least half would know the significance of the award. But if you ask them to identify the full name of the person the trophy honors, you may get only a smattering of correct responses. For the answer, readers are invited along for the ride—or should we say, *drive*.

Glenna Collett was born on June 20, 1903, into a family of sports enthusiasts living in New Haven, Connecticut. While an adolescent, the family moved northeast to Providence, Rhode Island, approximately a two- to two-and-a-half-hour car ride. Through the family's influence, Glenna learned to compete in amateur swimming and diving events. When she was fourteen, Glenna was introduced to the game of golf by her father, and that is when she found her true athletic passion. Recognizing enormous potential in Glenna's game, her parents convinced the renowned English professional golfer Ernest Jones to take her on as a student. Jones had recently started teaching golf because of the loss of his lower right leg by an exploding grenade in World War I. During his recuperation, he was able to reflect about the sport and came up with the following observations about the game: "That a golfer's brain would devise compensating strategies to yet produce fine golf shots" and "that the key to a successful golf shot was not the correct movement of certain body parts, but the correct movement of the club." Under Jones's guidance and instruction, Glenna's game improved such that in just two years, she was able to compete in the 1919 U.S. Women's Amateur Tournament. It would only take three more years before Glenna became the champion medalist in the same event.

Glenna grew up in an era when women's professional golf was but a dream. The only opportunity for talented female golfers during her era was playing in amateur events. But it wasn't about the money—never was. It was the competitive nature of the game that motivated Glenna and made her the golfer she quickly became. As former United States Golf Association president (1956–57) Richard Tufts said, "Glenna was the first woman to attack the hole rather than just to play to the green." She was also talented at hitting the long ball, something that the average woman wasn't good at up until that time. Perhaps Bobby Jones paid her the finest compliment when he said, "Aside from her skill…Miss Collett typified all that the word 'sportsmanship' stands for." It should come as little surprise that Glenna was called the "female Bobby Jones."

A 1934 image of Herbert Jacques and Glenna Collett Vare holding the Curtis Cup. *From an original wire service photograph by ACME Pictures, Inc., titled, "Herbert Jacques, Pres. U.S. Golf Assn. Receives Curtis Cup"; now in the author's collection (FLG).*

Glenna was once asked about the qualities she relied on to successfully play competitive golf. Ernest Jones's unique teaching approach and his strong influence obviously flowed from her lips, when she answered, "The three I have taken are these: love of combat, serenity of mind and fearlessness." She had learned her lessons well.

By the time Glenna finished her competitive golfing career, she had won six U.S. Women Amateur tournaments (1922, 1925, 1928, 1929, 1930 and 1935). By the time she was fifty-four years old, she had won a total of forty-nine championships (several international), the last of which was the Rhode Island Women's Golf Association Championship.

On her way up the leader board, Glenna met and married Edwin H. Vare Jr. in 1931. They had two children, Glenna Vare (Kalen) and Edwin C. Vare.

As for the Vare Trophy, it has been given in Glenna's married surname and has been awarded annually since 1953 to the golfer with the lowest scoring average on the Ladies Professional Golf Association Tour (LPGA) Tour. Glenna would also receive numerous other honors over her exemplary career. Perhaps her greatest honor came in 1975 when she was inducted into the World Golf Hall of Fame. If alive today, Glenna would probably argue, however, that her greatest accomplishment was having the privilege of breaking ground for female golfers in a sport that had been dominated by males.

Gene Sarazen once called Glenna "the greatest woman golfer of all time." Her inner drive, sparkling personality, competitive spirit and major golfing accomplishments throughout her long career make Sarazen's assessment difficult to argue against.

Glenna passed away in Gulf Stream, Florida, at the age of eighty-five. But if heaven has a championship golf tournament, Glenna is probably now standing on the sixteenth tee, two up with two holes to play, while contemplating her best strategy for victory.

A DIAMOND IS A GIRL'S BEST FRIEND

Wilma H. Briggs grew up on a dairy farm in East Greenwich, Rhode Island. While there, she learned her chores well. Besides milking the cows, feeding the animals, stacking hay and cleaning the barn, she became adept at something entirely different: playing baseball. When time permitted, Wilma's father hit a relentless barrage of ground balls at her and her brothers. Perhaps Wilma had little choice but to take part in the drills as her father was a semiprofessional baseball player and coach while a brother played in the minor leagues with the Chicago Cubs. It was during her father's time as coach of the Frenchtown Farmers that she first experienced the competitive nature of the game. She was only thirteen. Wilma's father often inserted

her into the lineup, giving her the opportunity to bat at least once and play defensively in the field; she batted left and threw right. It did not take long before Wilma blossomed in the sport. Three years later, she found herself playing competitive baseball in a high school boys' summer league. She was hooked. But achieving success in what was considered a male-dominated sport did not come easy. It took hours of practice and dedication, not to mention the bumps and bruises usually associated with being hit by a pitch or from sliding into bases. But Wilma was more than ready for the challenge.

Ironically, it would take a war to open doors for female athletes. As World War II raged in Europe and the Pacific, men from the United States either enlisted or were drafted into the armed services. With the available resource of professional baseball players depleted, the doors opened for women. However, the doors never opened wide enough to allow them to play in the major leagues. In 1943, through the foresight and showmanship of Chicago Cubs owner Philip K. Wrigley, an all-inclusive women's baseball league was formed that recruited skilled female baseball players from the United States, Canada and Cuba. It was called the All-American Girls Professional Baseball League (AAGPBL). The teams were predominantly located in the Midwest. As for uniforms, the women wore dresses resembling standard female gym uniforms of the 1930s and 1940s, with the hemline set at the middle of their thighs. Their hats were typical of those worn by male ballplayers in the major leagues.

Wilma was eighteen in 1948 when she heard about the league and that a number of officials were recruiting good players to fill team rosters. The opportunity came and went when Wilma chose to attend her graduation rather than travel to tryouts scheduled the same day in New Jersey. Undaunted, a short time later, her parents drove her to Fort Wayne, Indiana, where the last tryout of the season was held. The trip proved a resounding success. Wilma made the team. The following year, she became a utility outfielder and first baseman for the Fort Wayne Daises, where she remained under contract through the 1953 season. There she acquired the nickname "Briggsie."

What started as a novelty eventually transitioned into a major draw. The women's league drew over one million spectators the first season that Wilma played. The quality of baseball also improved each year. It was more excitement than Wilma could have dreamed.

Years later, when asked by a reporter from the *Providence Journal* how she was able to slide in a skirt, she responded, "We had shorts underneath, and besides, if you really slide at top speed, you don't get hurt. It's when you slow

When this image was taken by a baseball card company, the photographer asked Wilma to turn her face toward the camera and smile. She felt the pose made her look too feminine. *Courtesy of Wilma Briggs and Larry Fritsch Cards LLC.*

up and jump into the base, that's when you get hurt." She defined *hurt* as "getting strawberries" on your thighs.

When the first games were played, the baseball was softball-size. Through the years, it was gradually reduced to twelve inches and finally ten inches in circumference, roughly the size of a hardball. And what started as underhand pitching eventually became overhand, thus making it more reminiscent of men's baseball. But as skilled as the women became at the sport, they had to follow Philip Wrigley's creed: that each player was expected to display "the highest ideals of womanhood." The players were ordered to wear lipstick on the field, and after the game, they had to attend charm school. Also, as representatives of the league, they could not wear pants or drink alcoholic beverages off the playing field. They played for teams like the Battle Creek Belles, the Grand Rapids Chicks, the Muskegon Lassies, the Rockford Peaches and the Springfield Sallies. There was no mistaking the gender inclination to the team names in a male-dominated world.

But the league's popularity waned not long after the Korean War ended. After major league baseball began broadcasting games on television, the AAGPBL stopped pumping money into the venture. In 1954, the league folded, but not before Wilma hit a grand slam in a game that year while playing for the South Bend Blue Sox, the only year she played for that team. Her parents were said to be in attendance.

Wilma's lifetime batting average was a respectable .258. But her real achievements came via the long ball and through her defensive prowess on the field. Her fielding average was a stellar .963. Offensively, she hit forty-three career home runs, ranking her second in the power category in spite of not playing the first four years of the league's existence. Amazingly, twenty-five of those blasts were hit in the league's final season.

When her professional baseball career ended, Wilma returned to work on the family farm. Not long after, she went to college. After graduating, she secured a position as an elementary school teacher in Rhode Island. But Wilma never gave up her love for sports. She bowled and played golf and, of course, softball until the age of sixty-two. While reminiscing about her baseball exploits a half century later, Wilma told the *Providence Journal* reporter, "I always played with the boys," then added: "I was better than most of them."

As a fitting tribute, every girl who played in the AAGPBL—approximately 560 at best estimate—is now collectively enshrined in the Baseball Hall of Fame and Museum at Cooperstown, New York. And as you may have already surmised, the skills and courage of these young ladies was featured in the

1992 fictionalized Hollywood comedy-drama *A League of Their Own*. Twenty years after the movie's release, the National Film Preservation Board of the Library of Congress determined that the film was to be preserved in their registry because it was "culturally, historically, or aesthetically significant."

Wilma "Briggsie" Briggs is presently enjoying retirement but not in a sedentary way. At age eighty-three, she can be found on the lecture circuit, where she discusses her fond memories of years gone by as a professional baseball player to an enthusiastic audience. Still claiming East Greenwich as her home, she actually lives in a nearby town.

ALL THAT GLITTERS

It only seems fitting that women from Rhode Island would not only compete but also excel in swimming and diving events. Why? For years, Rhode Island has been touted as a summer vacation playground for swimmers, surfers and sailing enthusiasts. After comparing the state's extensive coastline with its diminutive landmass, it becomes dramatically evident why Rhode Island is nicknamed the Ocean State.

Although many Rhode Island women have participated in the Summer Olympic Games (thirty-two worldwide locations to date), the following six individuals have been the highest achievers in their fields. There is an exception, however. A potential gold medalist was unable to display her athletic prowess because of extenuating circumstances, the likes of which you will soon learn.

Born in Newport to a navy family, Aileen Riggin (Soule) was afforded the opportunity to travel extensively during her father's military career. While an adolescent, Aileen took a dedicated interest in both competitive diving and swimming activities. By the time she was fourteen in 1920, Aileen could already claim a gold medal in the springboard diving event at the VII Antwerp Olympic Games, thus earning the illustrious distinction as the youngest gold medalist at the event. Four years later, during the VIII Summer Olympic Games in Paris, she did the unprecedented by becoming the only women ever to medal in both swimming and diving events.

During the 1928 IX Winter Olympic Games held in Amsterdam, Albina Osipowich won two gold medals. At the time, she was a member of the Pembroke College Swimming Team at Brown University. While competing in the one-hundred-meter freestyle, she set a world record.

Also, as a member of a four-hundred-meter freestyle relay team, Albina received a second gold medal. Four years later, at the X Los Angeles Olympic Games, Helen Carroll, also a member of the Pembroke College Swimming Team, set a world record along with her teammates in the four-hundred-meter freestyle relay.

But not everyone's vision progressed as planned. In the late 1930s and early 1940s, E. Dorris Brennan (Weir) from Providence held twenty national and world records in swimming. As a member of the United States Olympic team in 1940, she was expected to win several medals while competing in the XII London Olympic Games. The ill-fated event, however, was never held. The event had to be cancelled because of the advent of World War II. Dorris's dreams of winning a gold medal remained only that—an elusive dream never to be realized.

Of course, there is always an exception to the rule, though not entirely. Jane Moreau (Stone), a Pawtucket native, won a gold medal in the 4x100-meter relay track and field event with her teammates at the 1952 Helsinki Olympic Games. The speedsters set a world record in the process. Jane also took to water but not in the Olympics by winning the Junior National Swimming Championship in the one-hundred-yard freestyle four years previous.

Born in Saunderstown, Elizabeth Lyon Beisel departed for London to participate in the 2012 XXX Summer Olympic Games. Publicly, Elizabeth was expected to medal in at least one swimming event, if not earn the gold. Her showing at the 2008 XXIX Beijing Summer Olympics, where she finished fourth in the four-hundred-meter individual medley and fifth in the two-hundred-meter backstroke, was expected to be a precursor of better things to come. Along with her memorable accomplishments after Beijing, which included a 2011 gold medal at the World Championships in the four-hundred-meter individual medley and a 2010 gold medal in the same event at the Pan Pacific Games, Elizabeth appeared ready for the challenge. When the time came, she not only performed well but also responded magnificently, setting a personal best in the four-hundred-meter individual medley. Her efforts, however, were only good enough to earn a silver medal, as she was defeated by a swimmer from the People's Republic of China who won the event by a whopping two seconds. Some questioned the Chinese swimmer's margin of victory, but in the end, the results remained unchanged. Through it all, Elizabeth maintained the true mark of a sportswoman. She never questioned the results; she only reveled in the medal she had won for herself and her country. During the same Olympics, Elizabeth also won a bronze

An autographed photograph of Olympic silver medalist Elizabeth Lyon Beisel. *Author's collection (FLG)*.

medal in the two-hundred-meter backstroke. With character above reproach and a smile to die for, Elizabeth not only represented the United States with dignity and honor but, equally important, also portrayed the true meaning of the "Olympic Spirit" represented by the five-ring Olympic symbol: friendship, fair play, honor, peace and glory.

IT'S A WOMAN'S JOB, TOO

I love to see a young girl go out and grab the world by the lapels. Life's a bitch.
You've got to go out and kick ass.
—*Maya Angelou,* Girl about Town, *1986*

FEMALE PRINTERS OF NOTE

All too often, women of earlier times were kept in the shadows of their husbands, neither seen nor heard. But that was not the case with the two women of this essay. Both came to the forefront of Rhode Island printing history not by choice but solely because of the death of their husbands.

Most eighteenth-century printing establishments were family-run affairs, with the husband as the primary printer and master of the shop. It was not unusual, however, for the printer's wife and children to perform many of the print shop's duties, like typesetting and running of the press, as well as ancillary print shop operations such as bookbinding and the selling of stationery. By operating the shop as a family-run business, the cost of hiring outside help was kept to a minimum. In a sense, all family members were responsible for running the business and for providing the necessities of life. Although the death of the head of the household was a serious blow to a family's well-being, at least a printer's widow would have all the skills needed to continue the operation. But keeping the business

profitable would not come easily. Succeeding in the printing profession would take a special kind of woman, as both Ann Franklin and Sarah Goddard would ultimately prove.

Although Ann Franklin is likely best known as the sister-in-law of founding father Benjamin Franklin, she is also credited as the first female printer in New England; a fact that is all too often overlooked. Ann married Benjamin's elder brother, James, in Boston in 1723. James was well known for his frequent confrontations with the Massachusetts Bay government and the clergy of Boston. For a time, he was imprisoned for his strong opinions expressed in his newspaper the *New England Courant*. Because of that, he was finally censured, causing him to list his younger brother, Ben, as the newspaper's publisher. James had a difficult relationship with his young teenage brother Ben, who served as an apprentice in a Boston print shop. But it was the precocious Ben, writing under the pseudonym "Silence Dogood," who not only created a stir but also increased the readership for the older Franklin's newspaper. Soon thereafter, Ben deserted his job and headed to Philadelphia to make his own way in the world.

James moved to Newport sometime around 1727 and set up his "Printing-House on Tillinghast's Wharf near the Union-Flag Tavern." Here he published, among other imprints, the first *Rhode Island Almanac* for 1728 by Poor Robin. With his move to Rhode Island, he became the colony's first printer. James died in 1735, leaving his wife and four young children—three daughters and the youngest child, a son, James Jr. Faced with the daunting reality of being deprived of a husband and staring at an uncertain future, Ann took over the family business. Assisted by her young daughters and existing print shop workers, she was determined to succeed. It wasn't long before Ann petitioned the General Assembly to become the colony's official printer. She may not have thought much about her endeavors as she was too busy managing a business and providing for her young family, but her accomplishments proved extremely noteworthy. Besides being the first female printer in New England, she was also the first female editor of a New England newspaper. Among her varied duties, Ann wrote content for her almanacs, and there is some evidence that she may have supplied her own woodcuts for the publication.

Ann singlehandedly managed the business until James Jr. came of age in 1748. James had previously spent time as an apprentice, having worked for his Uncle Ben. After reuniting with his mother, both managed the family business. For the next ten years, Ann remained actively involved in the trade, though imprints began to surface that displayed only her son's

ACTS
AND
LAWS,
Of His MAJESTY'S
COLONY
OF
Rhode-Island,
AND
Providence-Plantations,
In NEW-ENGLAND,
In AMERICA.

NEWPORT, RHODE-ISLAND:
Printed by the Widow FRANKLIN, and to be Sold at the
Town-School-House, M,DCC,XLV.

Title page to the *Acts and Laws of the Colony of Rhode Island*, printed in
1745 by Ann Franklin of Newport. *Author's collection (RJD)*.

name. For unknown reasons, invoices to the colony, however, continued to display both names.

Around 1758, James began to operate the business on his own, as evident by the removal of his mother's name from invoices provided to the colony. Ann was now sixty-three years old. No doubt, her rest was well deserved. It was well deserved, certainly, but her retirement was short-lived. James died in 1762, and Ann had to resume operating and managing the press. Deprived of help from her children as they had predeceased her, she employed Samuel Hall, a son-in-law, as a partner. Imprints began to appear under the name Franklin and Hall, but that, too, was short-lived, as Ann died only a year after her son's passing. Ann's death closed the final chapter in the challenging life of a truly remarkable woman who proved that she was well equipped to face the rigors of working and competing in a man's world.

There was another female pioneer printer from the state: Sarah Goddard. Sarah was to Providence what Ann Franklin was to Newport. Sarah's presence began shortly before Ann faded into history. Sarah was of old Rhode Island stock, having been born Sarah Updike at Cocomscussoc (North Kingstown), and was the great-granddaughter of Richard Smith, a friend and trading partner to Roger Williams. Sarah married Dr. Giles Goddard of New London, Connecticut, but after his death in 1757, she appears in Newport. Giles and Sarah's son William was born in New London in 1740. William commenced an apprenticeship in 1755 in New Haven, Connecticut, and by 1761, he completed his apprenticeship in New York. The following year, he established a business in Providence, thereby becoming the town's first printer. As noted in an essay by Nancy Chudacoff, "William resembled his contemporaries...he was printer, editor, publisher and bookseller." More likely, the financial backer to this business was Sarah. Although all imprints bear only his name, all invoices appear in both William and Sarah's names, leading one to believe that mother and son were business partners.

Soon after establishing the business, the press published the newspaper *Providence Gazette and Country Journal*, first issued on October 20, 1762. Up until this time, Providence—second to Newport in size and importance—had no newspaper; thus the press served a vital purpose. However, without the patronage of the colony's government (the Franklin Press in Newport held that lucrative contract), it was difficult for the Goddards to remain solvent. By early 1765, the newspaper was suspended, and shortly thereafter, William left for New York, where he joined the print shop of John Holt. By midyear, the *Gazette* reappeared under the name Sarah Goddard and Company. The company included Sarah's daughter Mary Katherine, who also

DIVINE PROVIDENCE

ILLUSTRATED and IMPROVED.

A

Thankſgiving-Diſcourſe,

PREACHED

(By Deſire) in the PRESBYTERIAN, or
Congregational Church

IN

PROVIDENCE, *N. E.* Wedneſday JUNE 4, 1766.
Being His MAJESTY's Birth Day, and Day of
Rejoicing,

OCCASIONED BY THE

REPEAL

OF THE

STAMP-ACT.

(Publiſhed at the Deſire of the Hearers)

BY

DAVID S. ROWLAND, M. A.
Miniſter of ſaid Church.

—————*The Lord reigneth, let the earth rejoice.*—————
King DAVID.
*As free, and not uſing your liberty for a cloak of maliciouſneſs, but as
ſervants of God.---Fear God,---honour the king.*
Ap. PETER.

PROVIDENCE, (NEW-ENGLAND)
Printed by SARAH GODDARD, and Company.

1766.

A 1766 title page from a book printed by Sarah Goddard in
Providence. *Courtesy of the Providence Public Library.*

worked in the print shop. In spite of his absence, William continued to maintain a legal interest in the business by virtue of the partnership. By all indications, the print shop prospered under Sarah's direction.

By early 1767, William had moved to Philadelphia, where he began another newspaper: the *Pennsylvania Chronicle and Universal Advertiser*. Also in the same year, Sarah took on a new partner in the person of John Carter. They printed and published under the name Goddard and Carter. The following November, Sarah—now nearly sixty-nine years of age—along with William, sold the printing business to John Carter. After the sale, Sarah went to live in Philadelphia. Whether because of age, illness or both, Sarah retired. She lived only a short time longer, dying on January 5, 1770.

Of the seven female printers in the colonies, Rhode Island, the smallest of the thirteen states, could claim two, both highly resourceful women: Ann Franklin and Sarah Goddard. Each left an indelible mark on the printing profession for years to come.

LIVING IN INTERESTING TIMES

"May you live in interesting times" is a phrase of Chinese origin that is said to be used as a curse. Arguably, Caty Littlefield Greene, the subject of this essay, and more so than any other woman featured in this collection, lived in interesting times, yet her life was not cursed. It does not seem possible that a young girl from New Shoreham (Block Island) would go on to marry the second-most significant general in the Continental army during the American Revolution; be on intimate terms with the likes of George and Martha Washington; know important members of the army, including General Henry Knox, General Horatio Gates, General Anthony Wayne and Marquis de Lafayette; and also have a close association with Alexander Hamilton and be acquainted with Thomas Paine. Then imagine being at the Siege of Boston in 1774 and at Valley Forge in 1776 while achieving all of the above before your twenty-fifth birthday. If that is not enough, imagine being the mistress of a large southern plantation and having as your guest Eli Whiney, who invented the cotton gin while staying at your homestead. Sound incredible? In fact, every word is true.

Catharine (Caty) was born to John and Phebe (née Ray) Littlefield on Block Island in December 1753. Life on Block Island must have been quiet and routine. It was mostly farms and not many more than fifty families, and

there were no schools. When Caty was only seven years old, her mother died. Shortly after, she was sent to live in Warwick on the mainland with her aunt Catharine, for whom she was named. Catharine Ray Greene was married to William Greene Jr., a member of Rhode Island's political elite, who later served as governor from 1778 to 1786. William's father had previously been a Rhode Island governor during the 1740s and 1750s. Aunt Catharine also rubbed elbows with the elite, and some say she had a more-than-friendly association (perhaps amorous) with Benjamin Franklin. While living with her aunt and uncle, Caty received some schooling while meeting more people than she would have had she remained at her former remote Block Island residence.

As she grew into a young woman, Caty met many eligible bachelors. One in particular caught her fancy: a young Quaker from nearby Potowomut by the name of Nathanael Greene. They courted and then married in July 1774. The couple moved into a new house that Nathanael had built in nearby Coventry, close to the family forge and anchor works. But the newlyweds were only there for a short while when in April 1775, Nathanael, a brigadier general in the Rhode Island militia, was called on to lead a Rhode Island brigade as part of the army of observation then encircling the British-occupied town of Boston. Caty stayed for a while with Nathanael in Cambridge, Massachusetts. While there, she visited with the Washingtons and socialized with other officers and their wives during evening dinners. It was during this time that Caty gave birth to her first son, George Washington Greene. Throughout the bitter campaign, Caty joined her husband whenever the opportunity arose. In 1776, she again joined Nathanael at winter quarters in Valley Forge.

When the protracted war ended in 1783, Nathanael had been away for more than eight years. The family's financial situation was dire, as many of Nathanael's business investments had failed. The Greene family moved to Newport after being forced to give up their home in Coventry. The short time they spent in Newport appears to have been pleasant, and Nathanael got to know his children better. It was the first time that he saw all of them at the same time. While on Aquidneck Island, they were often visited by friends, including those with whom they developed ties during the war, such as Generals von Steuben and Kosciusko.

In recognition of the great sacrifices made by Nathanael during his time leading the Continental army in the South, he was given land grants by the state legislatures of North Carolina, South Carolina and Georgia. In late 1785, the family moved to Mulberry Grove, a rice plantation in Georgia.

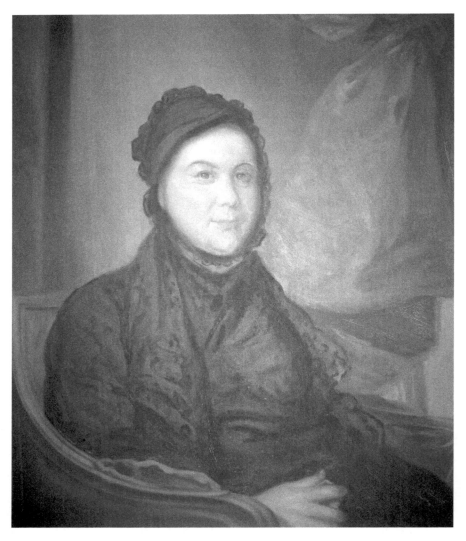

A painting of Catharine Littlefield Greene. *Courtesy of the Nathaniel Greene Homestead. Photographed by the author (RJD).*

There they hoped to establish themselves and, through the sale of crops and other property granted to Nathanael, work their way out of debt. Their dream of a long life together was short-lived. Nathanael died the following June of heat stroke; he was only forty-four years old. Caty, not quite thirty-three, found herself in an unenviable position, alone with five children to raise and a plantation to run. Fortunately, Phineas Miller, the young

Yale graduate who had been hired by Caty and Nathanael to tutor their children, took over the management of the plantation. Within a few years, the plantation was operating successfully. After ten years of widowhood and many opportunities to marry, Caty wed Phineas in June 1796. The official witnesses to her wedding were none other than George and Martha Washington. As interesting as Caty's life had been up to this point, she was soon to be involved in a major American invention.

Eli Whitney was a young tutor working at a nearby plantation when he befriended Caty and Phineas. Whitney was invited to stay at Mulberry Grove and work on his inventions. A partnership called the Miller and Whitney Company was formed, and not long after, Whitney's cotton gin was developed. Some unsubstantiated accounts suggest that Caty gave Whitney the idea of using combs in his invention to rid the raw cotton of seeds. The importance of this invention was significant. Some say it was the cause of extending slavery in the country; it certainly had an impact on cotton production in the South.

By 1798, Mulberry Grove was once again on hard times. The firm of Miller and Whitney had lost a substantial sum of money in a bad land deal. The plantation, along with many of its slaves, had to be sold. Caty and Phineas moved to Dungeness, another of Nathanael's properties located on Cumberland Island in Georgia. There Phineas died in 1803; Caty outlived him by another nine years.

Caty, the girl from Block Island, did indeed live in interesting times.

The Prisoner's Friend

When Sophia Robbins Little died in 1893 at the age of ninety-four, her obituary in the *Newport Daily News* noted, "The biography of such a woman with such connections would require a volume, and it will doubtless yet be written and given to the public." Unfortunately, no such volume has ever been written and most likely never will, though many historians can attest that Sophia deserved the honor. Today, her good deeds continue to live on.

Sophia was born in Newport in 1799, the daughter of Asher Robbins. Her father was a prominent Rhode Island politician who served as U.S. attorney general for Rhode Island from 1812 to 1820 and then in the state legislature for five years before serving as a U.S. senator from 1825 to 1839. Not much is known about her early education other than that she was

educated in the local schools of Newport. Those who knew her said that she had deep and thorough religious convictions, being raised as a member of the Society of Friends. Later however, she joined the Moravian Church because of its emphasis on personal sacrifice and service to humanity. In life, her religious convictions guided her and influenced her strong commitment to performing good deeds. As she once noted, "The missionary fervor and zeal of this church were prominent factors in the preparation for what afterwards became my life work." In June 1824, she married William Little Jr., a lawyer from Boston.

A gifted and prolific writer, Sophia wrote a number of poems along with several novels. One interesting and unsolicited testimonial to her writings is found in a letter from a young woman to her father in New Hope, Pennsylvania. Commenting on her stay at Newport in 1833, Caroline Corson noted: "Many of the ladies here have called on us—they are all *á la mode*—play on the piano & dance, generally I perceive nothing remarkably intelligent in any of them except a Mrs. Little daughter of Senator Robins [*sic*]. She is really a most agreeable and intelligent lady although a poetess." In fact, though Sophia was a renowned poetess in her time, she wrote with reform in mind. Her poems usually had a moral tale to tell. In her long antislavery poem "The Branded Hand," published in 1845, she wrote in its introduction, "This poem is founded on certain well known facts which have lately much affected the writer…I have given to the slaves that exaltation of character, which though rare, is seen among them. I preferred the intelligent slave, because the world is full of exaggerated caricatures of the African as slavery has made him—and I wished to contrast it by what I have seen under favorable circumstances." Her prose was equally full of social commentary as evident in her temperance novel *The Reveille*, published in 1854.

Sophia's writings reflected her interest in a number of social causes—she was actively involved in the antislavery, temperance and women's suffrage movements—but unquestionably, prison reform was her main interest. According to an account in *In Memoriam*, written by her friend Mrs. J.K. Barney, the author states that Sophia was a staunch defender of the slave. This fact is easy to verify by the many fugitive slaves she sheltered and cared for over time. Although the above implies she may have been an operative in the Underground Railroad, there is no other existing evidence to substantiate the claim. Early in life, Sophia began to visit prisoners in the local Newport jail in order to provide them some solace. She also visited prisoners in other nearby states. During the height of the Dorr Rebellion, when many prisoners were brought from Providence to be held in Newport's Marlboro Street jail, Sophia

made daily visits, taking to them small amounts of food, news, reading material and good cheer. She even communicated with the rebellion's leader, Thomas Wilson Dorr, who was incarcerated in Newport in 1844 while standing trial for treason.

As the nineteenth century was generally the age of great reform movements, it is not surprising that a wave of interest in prison reform took hold in the United States. In Rhode Island, with Sophia playing a leading role, a Prisoner's Aid Association was incorporated in 1874. The association consisted of both men and women whose purpose it was to aid discharged prisoners by assisting them with making an honest livelihood and to adopt such measures that were conducive for the prevention of further crimes. As Sophia noted in the 1881 annual report, "During more than forty years of experience in visiting our prisons, I have been constantly impressed with the need of a shelter for discharged prisoners in the dark interval between the prison door and the difficult beginning of a new life. It is in vain to preach Christ to them if Christian care and sympathy do not meet and guide them as they come out into the world again." A plan for a "Temporary Industrial Home" was suggested, but this plan ran into opposition from some members

The Sophia Little Home as featured on the cover of a 1913 annual report. *Courtesy of the Providence Public Library.*

of the society who considered it unsafe to receive men into their industrial home. An auxiliary society, the Women's Society for Aiding Released Female Prisoners was formed in 1881. To accommodate recently released female prisoners, a property called the Eldorado House (located near Roger Williams Park in Providence) was rented and aptly renamed the Sophia Little Home. Sophia was elected the new auxiliary society's first president. It was soon recognized that it was not practical to allow children to remain with their mothers for long periods in the industrial home. Therefore, in 1886, led again by Sophia, a new home to care for such children was opened. Its name was the Rhode Island Nursery Association for Homeless Infants. When initially urged to abandon this project—she was in her late eighties at the time—she declared, "Do not hinder me. I cannot die until it is done, and you must not keep me much longer out of the kingdom of heaven."

Her obituary summed up her life's interest well when it stated, "Mrs. Little long since became known as the prisoner's friend through her sympathetic efforts in behalf of prison reform…Again and again have we seen her, while bending under the weight of years, on her way to the Marlboro street jail… Her heart was in the work." During Sophia's life, the Sophia Little Home served as a halfway house, assisting released female prisoners. But during the twentieth century, the home took on a newer and equally important mission; it became a sanctuary for unwed mothers. Unquestionably, Sophia would have been pleased by the good deeds the society performed after her passing.

FIRST LADIES IN THEIR FIELDS

Toughness doesn't have to come in a pinstripe suit.
—*Dianne Feinstein,* Time, *June 4, 1984*

THE CHILDREN'S FRIEND

In the early 1830s, a missionary came to Providence to work among the destitute. The newly chartered city (1832) had some neighborhoods that were nothing more than dens of inequity. One such section was the waterfront neighborhood of India Point. The missionary was Harriet Ware, and this is her story.

Harriet was born in July 1779 in Paxton, Massachusetts. From all accounts, she had a normal childhood and was an average student in school. A memoir of her life written only a few years after her death noted that, in her early years, she was "gay and thoughtless, and wholly devoted to the search after pleasure." In contrast, her mother was a devout Christian and her father a man of high moral principles, though he did not profess a religion. Although Harriet showed no interest in religion initially, she more than made up for it around the time she turned twenty. No one knows for sure what caused her change, but she became deeply devout. Soon she moved to Franklin, Massachusetts, where she joined the Congregational Church lead by the Reverend Nathanael Emmons. There she devoted time to the study of

An engraving of the India Point section of Providence around 1840. *From* The History of Rhode Island. *Author's collection (RJD).*

the Bible and prayer while also attending private school. After finishing her schooling, she began work as a teacher in Union, Maine. Her time in Maine must have been short-lived, as she next turned up as a resident of Hopkinton, Rhode Island. There, having just turned twenty-eight years old, she commenced teaching in August 1827. Following this summer session, she was retained to teach during the winter months. By 1830, what little correspondence survives shows her in Cranston, Rhode Island. She must have earned a fine reputation as a competent teacher, for what happened next is what brought her to India Point.

By the spring of 1832, Harriet had arrived at India Point in Providence. Her memoir notes, "A lady who had become acquainted with her energy of character, her success as a teacher, and her single-hearted devotedness as a Christian, suggested to her this locality as a field of labor." In fact, Harriet was invited to set up school there by a group of benevolent ladies who had been engaged in providing pious teachers for the more destitute sections of the state. India Point certainly qualified as destitute; it was on the Providence waterfront and took its name from the East and West Indian sailing ships that docked there. By all accounts, it was no place for a lady like Harriet. Along with its wharves, the area consisted of dram shops, bawdyhouses, dilapidated houses and rowdy, unsupervised children. The sailors, fishermen and oystermen who lived and worked there could have easily been drawn from a Charles Dickens novel. Harriet set up school, and her first class consisted of seventeen children. But before long, it increased to nearly fifty. Soon she was also teaching night classes to the denizens of India Point, as many parents were also illiterate and solicited her for help. But Harriet quickly recognized that as hard as she worked, it mattered little as her student's home lives were too detrimental to their development and

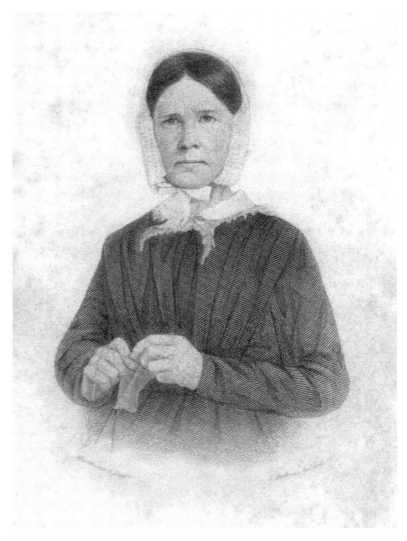

An engraving of Harriet Ware. *From* A Memoir of Harriet Ware. *Author's collection (RJD)*.

welfare. With parental consent, Harriet began to look for good Christian homes in which to place her students. Not all parents were willing to give up their children, but sufficient numbers did, and the first orphan service in Rhode Island was started.

By 1835, Harriet relinquished running her school and instead focused on overseeing a children's home where children could be housed, fed and

educated away from the deleterious influence of their parents and the evil lure of India Point. Her plan was "to provide for the support and education of indigent children, not otherwise provided for, and who for want of parental care are in suffering or dangerous condition." However, before Harriet could undertake her plan, she needed some financial help. As she had in the past, she sought the counsel of Dr. Francis Wayland, the president of Brown University and the minister of Providence's First Baptist Church. Dr. Wayland invited Harriet to meet with his ladies' Bible studies class. After hearing of Harriet's plan, these ladies pledged to raise funds, and soon Harriet had nearly $600 to open her home. On November 1, 1835, the home was opened at the corner of Broad and Stewart Streets, a good distance from India Point. Initially, the home had one boy under its care, but soon the numbers grew. The following year, the home was chartered by the General Assembly and became known as the Children's Friend Society. Near the end of the century, the home had cared for more than 1,600 children, a true success story.

Harriet remained as superintendent of the home until her death eleven years later. She, like her mother before her, had been diagnosed with cancer. After undergoing two unsuccessful operations, her death was imminent. Sometime during her final months, she made arrangements with a friend to assume care of one of the children whom Harriet had adopted. She died on June 26, 1847. Harriet was just forty-seven years old.

The organization still exists nearly 180 years after Harriet founded the Children's Friend Society. Now known as Children's Friend and Service of Rhode Island, the organization provides support to the most vulnerable children and families of the state. In recognition of its founder, the organization established a bequest program appropriately named the Harriet Ware Society. It is comforting to know that Harriet's benevolent work begun so very long ago continues to thrive with its mission. Surely, Harriet would be pleased.

A Dedicated Life of Social Reform

In 1891, forty years after her birth, Anna Garlin Spencer became the first woman to be ordained a minister (Unitarian) in the state of Rhode Island. From that year until 1902, Reverend Spencer served at Providence's Bell Street Chapel, a liberal, nondenominational church. During her lifetime,

Reverend Spencer wore many hats. She was an educator, a pacifist, a feminist (especially in the area of women's suffrage) and an activist to abolish child labor. She also fought for racial equality and justice. Adding to her already heavy workload, Reverend Spencer drafted commentaries on ethics and social reform.

Although born in Attleboro, Massachusetts, Reverend Spencer was raised in Rhode Island. In 1869, and only in her late teens at the time, she became

Reverend Anna Garlin Spencer. *Courtesy of Swarthmore College (Anna Garlin Spencer Papers, Swarthmore College Peace Collection).*

a journalist, writing articles for the *Providence Journal*. At the same time, she maintained a teaching position in the Providence public school system. In 1878, she married the Reverend William H. Spencer, a Unitarian minister. After a decade of marriage, his health failed and he became an invalid. Though no one knows for sure, his death in 1890 may have been the catalyst that helped formalize her religious ministry.

During her long and distinguished career, Reverend Spencer made a number of memorable and enlightening statements. Though a feminist, she was better able to voice her views under the guise of her ministry, usually without fear of retribution but not always. Some of her prolific words about women's rights are worth mentioning:

It is an old error of man to forget to put quotation marks where he borrows from a woman's brain!

Can a woman become a genius of the first class? Nobody can know unless women in general shall have equal opportunity with men in education, in vocational choice, and in social welcome of their best intellectual work for a number of generations.

Of all the wastes of human ignorance perhaps the most extravagant and costly to human growth has been the waste of the distinctive powers of womanhood after the child-bearing age.

At times, Reverend Spencer may have seemed too outspoken, especially to males whose authoritative rule in the late nineteenth and early twentieth centuries was slowly weakening. According to one source, Reverend Spencer was mentioned in a 1928 Federal Bureau of Investigation (FBI) report. In it, the FBI noted the need to monitor a woman named Carrie Chapman Catt, who was a leader in the women's suffrage movement. The fifty-seven-page report described Ms. Catt as a "supporter and advocate of subversive propaganda." Her main offense: Ms. Catt was a world peace activist and considered a potential threat to the nation's welfare because of her "association with radicals." Reverend Spencer was mentioned as one of them.

Two of her more prominent works included *Woman's Share in Social Culture* (1913) and *The Family and Its Members* (1922). Both books made a definitive impact on women, who for years had conformed to male role expectations of the time.

Reverend Spencer was not only a writer but also a public speaker, spending many days on the lecture circuit while expounding her beliefs. Her greatest contributions came, however, as a member and leader of a multitude of organizations dealing with women rights, peace and social reform. Some of the more notable organizations included the Rhode Island Equal Suffrage Association; the Rhode Island Woman's Peace Party, which she founded in 1915 and served as vice-chairman; and the Women's International League for Peace and Freedom, serving as its first chairman in 1919. As her influence grew, she became friends with many other influential ladies, the most noteworthy being Susan B. Anthony. Wanting to be closer to the action, she moved to New York, as it was the focal point of activity for women's reform issues for a number of years. It is interesting to note that Reverend Spencer was one of the original signers of the call to establish the National Association for the Advancement of Colored People (NAACP).

From 1902 through the next few decades, Reverend Spencer lectured at a number of colleges and universities. Prior to her death in 1931, she had served as a guest lecturer on social issues at Columbia University.

A MEDICAL BREAKTHROUGH

Donning a "fresh, clean, calico dress," Dr. Anita Tyng meticulously washed her hands in carbonized water before operating on her patient. Only women were present in the hospital operating room that day. The patient lying on the table was having her ovaries removed by abdominal section to halt the growth of a uterine fibroid. Hours later, the patient was in recovery. Months after the successful operation, Dr. Tyng presented the results of the operation and the protocol to members of the Rhode Island Medical Society of which she was the first female fellow. Dr. Tyng's operation "was the first case of the kind ever reported to our Society," wrote a doctor whose comment was published in the *Providence Medical Journal*. The noteworthy operation had taken place in a Providence hospital in October 1888.

Dr. Tyng's success as a physician and surgeon did not come easily considering her gender. At the time, women were thought to be too dainty for such a difficult and demanding profession. Those who had their doubts about her ability and perseverance would eventually be proven wrong. But before she and a few other pioneering ladies broke the gender barrier, women were relegated to much lesser roles, usually as nurses. Nursing duties

The Woman's Medical College of Pennsylvania. *From* History of the Woman's Medical College, Philadelphia, Pennsylvania, 1850–1950.

in the 1860s were normally limited to simple tasks such as cooking, cleaning and laundry, though women did act as midwives.

Dr. Tyng was born in Providence, but the exact date of her birth remains uncertain. Although her early life went undocumented, it is evident that she strove to become a doctor as early as her teen years. According to an article in the *Spokane Daily Chronicle* of June 19, 1935, Dr. Tyng became "the first [woman] appointed on a hospital staff in America" (the New England Hospital for Women and Children in Boston). It would take another decade before a second woman, Dr. Annette Buckel, would be appointed at another hospital.

In 1866, Dr. Tyng applied for admission to Harvard Medical School to enhance her medical knowledge. She had already graduated from the Women's Medical College of Pennsylvania and was currently working on the staff of the New England Hospital for Women and Children in Boston. Politely, she was informed, along with another female applicant, that "no provision was made or exists for the education of women in any department of the University." Her application to Harvard Medical School was not the first for a female. A request was made for admission by another young lady as early as 1847. She was denied admission because regulations at the school implied "that the students are exclusively of the male sex."

Detail image of a female
medical student operating
on a cadaver. Frank Leslie's
Illustrated Newspaper,
April 16, 1870.

It was not long before Dr. Tyng returned to Providence. Upon arrival, she found that there were no other trained women practicing medicine in the city. During her stay, she managed to earn the admiration of numerous learned men within the medical profession.

In 1870, Dr. Tyng applied to the Rhode Island Medical Society for admission. Her request was denied. Although there were twenty-five "yeas," there were also fifteen "nays." To be accepted, she needed two-thirds of the vote. In December 1872, she reapplied. This time she was granted membership into the elite organization of doctors (Kansas was the first to appoint a woman as a member of a state's medical society). Over the ensuing years, Dr. Tyng published countless medical papers, joined in medical discussions and reported "interesting cases" to the organization. While still in Providence, she was credited with helping countless female medical students to realize their dreams of becoming doctors. On a larger scale, working alongside other society members, she helped establish a state board of health.

Looking for more opportunity, she left Rhode Island to become a surgeon at Woman's Hospital in Philadelphia, Pennsylvania. The move became a wise career choice. Subsequently, she became the medical director of the hospital. Years later, she journeyed to hospitals in Florida (the greater portion of her final thirty years were spent there) and then on to California.

Before her career ended, Dr. Tyng could claim several professional achievements. Besides becoming the first licensed female surgeon in America, she also became a founding member of the American Medical Association. Later, she helped to establish schools for women seeking to become doctors. Dr. Tyng was also considered the nation's leading expert on reproductive health and her stance as an antiabortion advocate was well known during her lifetime.

On October 16, 1913, Dr. Tyng died at the age of seventy-six in Berkeley, California. Skin burns, the nature of which went undocumented, and advanced age hastened her death. A contemporary admirer said years after the doctor's passing that based on her achievements during her lifetime, Dr. Tyng should be considered one of the "most influential women in America." Though some may argue otherwise, there is no denying that her gender breakthrough in a medical profession previously dominated by males was both admirable and remarkable.

MOTHER, ENGINEER AND INDUSTRIAL PSYCHOLOGIST

Lillian Moller (Gilbreth) lived in a time when business careers and motherhood did not mix. Yet Lillian would dispel the notion held by a majority of turn-of-the-century males that "a woman's place was in the home."

The first of nine children, Lillian was born in 1878 into an affluent family in Oakland, California. Her father brought her up to believe that college was unnecessary for a woman of financial means. Lillian, a shy introvert, reinforced that sentiment by also believing she was rather plain looking and that "no one would marry her." She was, however, a brilliant student. In spite of her father's conviction, Lillian attended the University of California at Berkeley as a day student, majoring in English literature while taking courses in foreign languages, philosophy and psychology. In 1900, she graduated with a degree in teaching. Because of her high academic standing in the

class, she garnered the privilege of delivering the commencement address, the first woman to do so at Berkeley. With an unquenchable appetite for education, Lillian decided to pursue advanced degrees.

After a brief stint at Columbia University in New York, she became ill and returned home to California. After recuperating, she enrolled at her alma mater where, in 1902, she graduated with a master's degree in English literature. But now her educational aspirations grew even larger. She applied for and was accepted into the doctoral program at Berkeley, where she majored in English. Additionally, with a fascination for psychology, she chose that course of study as a minor.

During summer break the following year, she journeyed to Europe with a group of young women. After stopping in Boston, she was introduced to a man named Frank Gilbreth, a successful contracting engineer with offices in the New York/New Jersey area and London. After returning from her trip, she met him again, and in spite of the eleven-year age difference, they fell in love. After a brief courtship, they married in 1904.

Lillian never received a doctoral degree from Berkeley. An unexpected obstacle surfaced that proved insurmountable. She was dropped from the program because of noncompliance with the school's residency policy. The policy set down that doctoral candidates were required to live in the state of California during their final year of study. To be closer to their business interests in the New York metropolitan area, the Gilbreths had been living in Plainfield, New Jersey. Sadly, Lillian was within striking distance of the degree, having recently completed her dissertation.

After Lillian's immediate family relocated to New England, the Gilbreths and their ever-growing family followed suit and moved to Providence. In 1912, they set up a management consulting firm with Lillian as an adviser and junior partner. The original contracting firm (Gilbreth, Inc.) had fallen on hard times due to an unstable economy and had to be dissolved.

While living in Providence, Lillian yearned to obtain a doctorate degree. With her husband's support, she applied to Brown University and was accepted. In 1915, she graduated with a PhD, thus becoming one of the first women to receive a degree in industrial psychology. But her achievement is greater than it appears. Lillian completed her studies while still working with her husband as a consultant and as the matriarch of a large family. Before her childbearing years were over, the Gilbreths were the parents of twelve children.

It was Frank who first convinced Lillian to change fields and become both an engineer and an industrial psychologist. At the time, the couple

became interested in scientific management techniques following the lead of Frederick Winslow Taylor. But Taylor's work was limited and dealt with only the time-study aspect and not the process of motion. While working as a team at their home office and later in the field, they devised innovative time and motion studies along with efficiency techniques. Using a movie camera, the Gilbreths documented the motions of handicapped people and World War I amputees to improve physical therapy techniques. Then they turned their interests to factories, where they used their techniques in manufacturing processes, not simply to speed up the system but also to improve the well-being of the workers. Their innovative approach, though not without critiques, will always be remembered as advancing the field of management by better understanding the human element in the workplace.

In Providence, the new consulting firm secured a contract with the New England Butt Company to apply its new scientific methods. The manufacturing company built machinery for braiding and stranding wire. Today, only a building stands on Pearl Street where the business once operated. In 1980, it was recognized by the National Registry of Historic Places. The Gilbreths remained in Rhode Island for seven and a half years in what was said to be a very productive and rewarding period in their partnership. Unfortunately, Frank died in 1924.

Now head of the consulting firm, Lillian went back to college and obtained a master's degree in engineering followed by a doctorate in engineering and science. But her acceptance as a female consultant in a man's world met with stiff resistance. Undaunted, Lillian made a conscious decision to analyze domestic issues instead of manufacturing engineering concerns. By so doing, she turned her home into a laboratory that involved her own children and that, in the end, changed the way housewives performed their daily routines. According to Laura Meade Kirk in a *Providence Journal* feature article, titled "A Career of Firsts for Mother of 12," Lillian "helped design modern kitchens, to make housework more efficient." After interviewing approximately four thousand women, Lillian took the results and redesigned kitchen ranges, countertops and sinks to a more functional height. As Kirk observed, "Ironically, she barely knew how to cook, since she'd had servants all of her life." Adding to her accomplishments, Lillian also designed useful and innovative devices from door shelves on refrigerator doors to foot-pedal trashcans.

Her son Frank Gilbreth Jr. and her daughter Ernestine humorously documented their large family's exploits in the bestselling book *Cheaper by the Dozen*. The subsequent film became an instant comedy sensation when it was

Lillian M. Gilbreth

This remarkable woman combined many talents to become known as the "First Lady of Engineering."

Lillian Moller Gilbreth was immortalized by the U.S. Postal Service on this First Day Cover with a postage stamp bearing her image. *Author's collection (FLG).*

released in 1950. The latest film adaption (2003), released under the same title, bears little resemblance to the original screenplay, however.

At the end of her career, Lillian was hailed as the "First Lady of Engineering" and the "Mother of Modern Management." Though some might argue there were other worthy candidates for the engineering distinction, at the very least they had to admit that Lillian was one of the first industrial psychologists of her gender and certainly a pioneer in that field.

Throughout the remainder of her life, Lillian continued to add to her illustrious credentials, not the least of which was teaching as a professor at several prestigious universities throughout the country. Amazingly, while in her eighties, Lillian continued to travel throughout the world. When she died in Phoenix, Arizona, on January 2, 1972, at the age of ninety-three (forty-eight years after her husband's passing), she left a legacy that any person would be proud to showcase.

A NATURAL PROGRESSION

More often than not, the baby of the family has an inclination to overachieve. Isabelle Ahearn O'Neil is no exception.

The last of thirteen children, Isabelle was born in Woonsocket sometime during the year 1880. Twelve years later, her parents moved to Providence. Her father was a wholesale horse dealer with sales depots throughout the state. Though she enjoyed horseback riding, Isabelle aspired to become an actress. While in her teens, she left for Boston College to study drama and oratory and then law at Harvard. After returning in 1900, she established her own school: the Ahearn School of Elocution. Students under her supervision were required to take subjects such as oratory, drama and physical education. Later, she became an instructor at several parochial schools in the area. During this time, she expanded her interest in theater by joining the Empire Summer Stock Company. Finding the acting profession to her liking, she joined successive stock companies in Albany, Troy and Brooklyn, New York. In 1907, she met John A. O'Neill. They had one child who died at the age of three. The couple soon divorced, but for some unknown reason, Isabelle kept her ex-husband's surname.

It was about the time of her divorce that Isabelle became a star on Broadway. Four years later, she joined the Eastern Silent Film Company before performing on the vaudeville circuit in a one-act dramatic play titled *Heart's Ease*. No one is sure why, but Isabelle eventually gave up the acting profession.

Returning to Providence, Isabelle—whether purposely or not—brought along her name recognition. Earlier, while lecturing in New York, a friend called and asked for her support by using her name while campaigning for a position on the Providence School Board. She granted the request but not before rethinking her own destiny. She must have thought, *If someone else can get elected by using my name, why can't I?* Soon, she was nominated by the Democrats to run for a seat as a representative in the Fifteenth Assembly District, a position to which she was elected in November 1922. According to Isabelle, it was "the last thing I ever dreamed of." Some may say the career change from actor to politician seemed like a natural progression, especially for a woman. Perhaps she thought the same. With her victory came the distinction of becoming the first female representative for the state of Rhode Island. While some states, especially western states, had allowed women the franchise in the latter part of the nineteenth century, it was not until the passage of the Nineteenth Amendment that women could vote in Rhode Island. Remarkably, Isabelle was elected only two years after the amendment was passed. Presumably, many female voters within her district tipped the scale in her favor. Just two years later, she would become chairman of the 1924 National Democratic Convention at Madison Square Garden. After eight years in the House of Representatives, Isabelle was elected as a senator

A detail image of Isabelle Ahearn O'Neil taken on the campaign trail in 1932. *From an original wire service photograph credited to ACME and NEA, titled "Woman Democrat Starts Campaign Tour"; now in the author's collection (FLG).*

from the Fourth Providence Senatorial District. After reelection in 1932, she became the deputy Democratic floor leader.

While serving her state in both the House and Senate, she introduced a number of bills to the floor. Some of the more noteworthy are the Rhode Island Narcotic Drug Act and the Widow's Pension Act for mothers with dependent children, as well as bills regarding jury service for women, equal pay for public school teachers, teacher pension increases, improved labor laws and the establishment of the Rhode Island State Police.

In 1933, President Franklin D. Roosevelt appointed her as a legislative representative for the Bureau of Narcotics, U.S. Treasury Department in Washington, D.C. Two years later, she traveled to Europe to consult with Scotland Yard, the French Sûreté and other international investigative agencies. According to Isabelle, the trip was undertaken "to obtain international cooperation with the U.S. for control of the growth of narcotic substances and laws effecting drug addiction and illicit sales." Her visit met with considerable success. But in 1943, she resigned from the Bureau of Narcotics to be with her family back in Rhode Island and to serve as an executive for the Rhode Island Department of Labor. She continued to stay active in a number of city and state organizations, political and otherwise, almost until her death at the age of ninety-four in 1975.

During her lifetime, she had found her stage, not just as a flourishing actress but also, and perhaps more importantly, as an influential politician.

You Are Now a "Person"

Born in Providence on March 3, 1892, Ada Lewis Sawyer was brought up in a typical American household. She came from a nurturing family and had three siblings to play with during her childhood. Her father supported them by working as a salesman for a local oil company. Her mother was a homemaker. After completing elementary school, Ada went to Providence English High School, where she graduated with honors in 1909. Fortunately, a day after graduating, she was hired as a stenographer at the law office of Charles E. Salisbury and Percy Winchester Gardner. A year later, Gardner separated from his partner and started his own firm. Ada decided to go along for the ride. She became his personal secretary.

While working at the firm, Ada showed an interest in "reading law." Apparently, her intelligence and drive impressed Gardner such that he encouraged her to pursue the profession. In 1917, as the time seemed right, Gardner registered her as an applicant to take the state's bar examination. In order to qualify for the examination, a candidate had to have graduated from an accredited college and/or graduate school or have read the law for three years. Gardner filed her application noting the latter. But before Ada was able to take the examination, the board of examiners noted that she was a woman. The board members' decision to disallow her application was based on the premise that the word "person" written in the bar rules was intended

to identify only those of the male gender. The legal squabbling commenced almost immediately, and before long, the case was heard by the Rhode Island Supreme Court. A final decision ruled in Ada's favor. The decision was not intended as a victory for Ada alone but more so for all Rhode Island women who had or would have aspirations to enter the legal profession and become attorneys. Associate justice William Sweetland, later chief justice, issued the court's findings: "After consideration we are of the opinion that the word 'person' contained in the rules regulating the admission of attorneys and counselors should be construed to include a woman as well as a man," while adding "that the masculine pronoun 'he' contained in the rules should be construed to include the feminine 'she.'"

Ada took the bar examination on September 24, 1920, thereby becoming the first woman in the state to do so. Approximately seven weeks later, Ada was informed that she had passed. Of the twenty-two candidates who took the exam, only twelve passed. Her acceptance into the state bar came just two and a half months after the ratification of the Nineteenth Amendment to the U.S. Constitution that gave women the right to vote. In noting Ada's accomplishment, the *Providence Journal* called her the "Providence Portia" (in William Shakespeare's play *The Merchant of Venice*, Portia disguises herself as a man and assumes the role of a lawyer's apprentice in order to save a friend's life in court). In spite of the exuberance, Rhode Islanders must have wondered why it took so long to admit a woman to the state bar, as it was one of the last states in the nation to do so.

Transitioning from a secretary to a lawyer did not come easy for the young professional. However, those who felt women were unfit for the profession would quickly be proven wrong. According to an article printed in the *Providence Evening Bulletin* dated April 7, 1921, and cited in Denise Aikens's essay published in the spring 2011 edition of the *Roger Williams University Law Review*, Ada said, "[I]t may be interesting to know that there have been twice as many women as men to consult me; and that those of my own sex who have come to me, not only have evinced confidence in me, but have preferred to talk with a woman rather than a man."

After admission to the bar, Ada remained with Gardner's law firm until his death in 1955. Along with new partners, and for years thereafter, she worked on trust, banking and probate cases. Before her career ended, Ada had given the profession sixty-three years of her life. During her illustrious career, she garnered many awards that are too numerous to mention. But it would be remiss not to mention one of the finest tributes paid in her honor: the Rhode

A detail image of Ada Lewis Sawyer taken from an original
photograph. *Courtesy of the Rhode Island Bar Association.*

Island Woman's Bar Association named its "Award for Excellence" after Ada
Lewis Sawyer.

Ada never married and lived with her sister, Bertha, for most of her adult
years. After suffering a stroke, Ada began to slow down some, but she did not
stop practicing law. She continued to work until the age of ninety-one before
finally retiring. Two years later, on May 14, 1985, she passed away. Her last
partner, Jim Sloan, recently retired.

THE SOFT-SPOKEN JUDGE

We have all walked by a public building, noticed the name for which the building was dedicated on a sign and passed it by without giving it a second thought. There are many such buildings in Rhode Island, as there are in all the states. In Rhode Island, one building at Washington Square in Newport is named in honor of the first female member of the Rhode Island Supreme Court. Formerly called the Newport County Courthouse, the name was changed in 1990 and is now known as the Florence K. Murray Judicial Building—the first time that a major court building in the United States was so named for a woman.

Florence K. Kerins was born in Newport on October 21, 1916. She attended Rogers High School in Newport, where she became an active member of the History Club (secretary/treasurer) and the Varsity Debate Team and wrote for the school newspaper. After graduating from secondary school, she went on to study at Syracuse University in New York. At Syracuse, Florence wrote for the college's quarterly magazine, the *Syracusan*, and served in various capacities during her senior year: nonfiction editor, fiction editor, personnel manager, feature editor and managing editor. She graduated with a bachelor of arts degree.

After college, Florence worked briefly as a teacher in a one-room schoolhouse on the small island of Prudence, just off the coast of the Rhode Island mainland. Reminiscing about her experience years later, she told Marian Mathison Desrosiers in an interview that was later published within Desrosiers's doctoral dissertation: "Although my first job teaching gave me a chance for hard work and adventure, I knew what I wanted; to go to law school." Previously, Florence had been encouraged by a former professor to pursue a law degree. Finally taking his advice, she went on to study at Boston University Law School, graduating in 1942 with a bachelor of laws degree. Shortly thereafter, she was admitted to the Massachusetts Bar Association.

With the war raging, Florence decided to do her patriotic duty. She applied and was accepted to Officer Candidate School and after graduation became a commissioned officer in the Women's Auxiliary Army Corps (WAAC). She never left the States; her duty stations were in Iowa, Florida, Georgia and Washington, D.C. Before separating from the army in 1945, she held the rank of lieutenant colonel. Subsequently, she was recalled to active duty in 1947 for a brief assignment before receiving her final discharge. Her time in the service was extremely worthwhile, as she gained crucial leadership experience while assigned to various command posts that would help her

Major Florence K. Murray as she appeared in early 1944 during World War II. *From an original wire service photograph, titled "Major Florence K. Murray; WAC Chief," published in the* Baltimore Sun; *now in the author's collection (FLG).*

realize her ambitious goals as a civilian. Arriving back home in Rhode Island, Florence commenced practicing law along with her husband, Paul F. Murray, whom she married in 1943 (Florence had previously been admitted to the Rhode Island Bar Association).

It seemed that Florence had held political aspirations for a while. Initially, she served as a Newport School Committee member before running as a Democrat for a state senate seat. When she won the election, Florence became the second woman to serve in the Rhode Island Senate. She served in that capacity from 1949 to 1956. In 1952, she was named a delegate to the Democratic National Convention. Four years later, Florence became the first woman appointed as a Superior Court judge in the state. After working in this capacity for twenty-two years, Florence was appointed chief justice of the Rhode Island Superior Court. Less than a year later in 1979, she was elected as an associate justice of the Rhode Island Supreme Court, thus becoming the first female to chair that position not only in the state but also in the nation.

Florence's success while on the bench was personified by her intelligence, common sense and low-key approach to solving difficult issues. Though soft-spoken, she was able to carve out an admirable record of judicial accomplishments during her long tenure while serving the citizens of Rhode Island.

Florence's husband, Paul, died in 1995. Less than a year after his passing, she retired from the bench. Florence lived another nine years before dying in Newport on March 28, 2004.

In her honor, the Florence K. Murray Award is given by the National Association of Women Judges and presented annually "to a non-judge who, by example or otherwise, has influenced women to pursue legal careers, opened doors for women attorneys, or advanced opportunities for women within the legal profession."

A Spirited Woman

When Susan L. Farmer walked into a room, she lit it up like no other Rhode Islander past or present. Yet there was no single quality about her that set her apart from any other. Arguably, it was the combination of many factors, and the most obvious may have been her beauty. With stunning blond hair, high cheekbones and piercing blue eyes, she was pleasant to the eye. But for those privileged to know her, it was much more than her looks that carried her to the forefront.

Described as extremely intelligent, Susan was also tenacious, rarely taking "no" for an answer. In an article by Andrew Lapin published by *Current*,

Skip Hinton of the National Educational Telecommunications Association is quoted as saying: "She was a trusted voice…[and]…also a very persistent voice. She didn't back down in making her argument."

Others called her upbeat, trustworthy, adept at public relations and a born leader; all would fit. And just about everyone who knew her would have to agree that she displayed a playful demeanor that tended to put everyone at ease even during difficult negotiations.

Considered a "preppy," she came from the affluent East Side of Providence. She wore pearls, fashionable designer clothes and was educated at the prestigious Wheeler School before going on to Simmons College. Yet she never downplayed her image as a woman of means. In truth, she crafted it into an enormous asset, melding her image as a woman of means into a woman of substance.

Although Susan had some political exposure when she became Senator John Chafee's finance director in 1976, in many ways, she was still a political neophyte. Her first real test in the state limelight came as a Republican candidate for secretary of state, an election she lost to the Democratic incumbent. Two years later, she ran again and won. In so doing, she became the first woman to hold statewide office. After two years, she was reelected, this time besting her Democratic opponent (a woman). According to the Rhode Island Heritage Hall of Fame, while holding the office, Susan "introduced technology to the office, purged the voting rolls, and received national acclaim for her voter education program in the classroom." In 1986, after setting higher political aspirations, she ran for the office of lieutenant governor but lost the election. However, the loss led to a much bigger challenge that eventually benefitted the entire state.

Later that same year, Susan was offered the position of general manager of Providence's WSBE Channel 36 (today the Rhode Island Public Broadcast System). There were some who felt that Susan would be nothing more than a caretaker to an educational channel that had been failing for years due to an underfunded budget. These same individuals would quickly learn that Susan was no pushover. In an article by Steve Behrens in *Current*, an "incident in the parking lot last April [1990] has achieved the status of minor legend, though the details have been mangled by retelling." The distorted version reveals that Susan hid in a barbershop doorway while lying in wait for the governor, who was eating at a sandwich shop nearby so she could "catch his ear." Though Susan denied this account, some people still enjoy hearing this enhanced version more than what actually transpired. According to Susan, she had received a call officially putting her on notice

A detail image of Susan Farmer as a Rhode Island political figure. *Photographer: Bob Breidenbach, 1988.* Providence Journal, *September 20, 2013. Copyright © 1988, the* Providence Journal. *Reproduced by permission.*

that the public broadcasting station was being "zero-funded" for the coming year. In addition, she was told the station would have to close shop by May 15. After repeated tries to meet the governor and with only thirty-six hours before the governor's budget was due at the printers, Susan, through some

quick detective work, found out where the governor would be eating lunch the next day. Sure enough, when the governor finished his meal and came out of the restaurant, she was standing in front of his limousine to confront him. Susan was smart. She brought along a small entourage of reporters. Immediately, she begged the governor for more "time to look for outside funding." After making several positive points about how the station benefited its citizens and the fact that, if the station closed, the mortgage for the new headquarters building for the station would still have to be paid at a cost of $800,000 a year, the governor appeared sympathetic, though he reserved final judgment. That same afternoon, the governor called Susan and asked her what minimum budget she would need to effectively run the station. She gave him a number. After saying he would give it more thought, the governor called Susan again; she would be given "75 percent of an already-reduced appropriation." It was a larger victory than the numbers indicated. She had saved the station, though she knew considerably more needed to be done to keep it on the air for the following years. Immediately, she set out to increase fundraising activities for the nonprofit state-owned network. That effort met with great success, though there was a paradox. According to Richard C. Dujardin of the *Providence Journal*, "The irony was that the more money she raised, the more opportunity politicians had to trim her budget."

Susan was also credited with creating a weekly public-affairs show called *A Lively Experiment*. Today, it is still on the air. The show continues to carry frontline issues of importance to Rhode Islanders that Susan was proud to air. Before her career ended, Susan proved to be a positive force in making long overdue changes within the state.

In 2001, Susan was diagnosed with cancer that turned into a courageous twelve-year battle. With the weight of the illness hanging over her, she retired from the station in 2004. When Susan died at the age of seventy-one on September 16, 2013, she left the state of Rhode Island and its citizens a pair of shoes that would be extremely difficult to fill.

Chapter 11

OTHER ACHIEVERS

A woman is the full circle. Within her is the power to create, nurture and transform.
—Diane Mariechild, Mother Wit, *1989*

"THE BRAVEST WOMAN IN AMERICA"

It was a cold, blustery day when four lads decided to sail their small boat between Fort Adams and Lime Rock in Newport Harbor. For reasons unknown, one hardy but foolish young man of the crew climbed the mast and deliberately began shaking the sailboat until it became unstable. Perhaps he was trying to frighten the remaining three onboard with his high jinks. He did just that. In a matter of seconds, the boat took on water and capsized. All four began treading water near the overturned boat with nothing on their mind but sheer survival. Witnessing the episode from a lighthouse on Lime Rock, a seventeen-year-old girl reacted quickly. She jumped into a rowboat and rowed toward the helpless crew. One by one, she pulled each from the chilly water into the rowboat before returning to the lighthouse. The boys, drenched and exhausted, walked up the rocks into the lighthouse. The female rescuer gave each "a stiff dose of hot molasses" while they warmed themselves by the fire.

The lifesaving event received only scant press coverage in 1858, and as the young lady later reminisced, "I did not think the matter worth talking about

Ida Lewis, the young lighthouse keeper from Newport, Rhode Island, was pictured on the front cover of the July 31, 1869 edition of *Harper's Weekly (A Journal of Civilization)*. She was touted for her heroic exploits on Narragansett Bay. *Courtesy of the Library of Congress.*

and never gave it a second thought." That rescue would be the first of many. Officially, our heroine would be credited with saving eighteen lives from treacherous waters, although some say it was twice that number in reality.

Born in Newport, the second of four children of Captain Hosea Lewis and Idawalley Zoradia (Willey) Lewis, our heroine became one of the first female lighthouse keepers formally appointed to the U.S. Lighthouse Service, a predecessor of the U.S. Coast Guard. Her first and middle name was the same as her mother: Idawalley Zoradia. For short, she was called Ida.

Ida's father, Captain Lewis, was lighthouse keeper at the Lime Rock Light for only four months in 1857 before he suffered a debilitating stroke that left him wheelchair-bound until his death in 1872. Ida's mother took over the duties from her husband with the help of her daughter Ida. Each day at sundown and again at midnight, the ladies filled the lamp with kerosene. At dawn, they extinguished the beacon. In between, the wick needed to be trimmed and the lamp reflectors cleaned and polished. The ladies made certain that the beacon was always well maintained.

In 1877, Ida's mother's health began to fail, and because of it, Ida was formally appointed lighthouse keeper in 1879 (Ida's mother died a decade later). Eventually, Ida would go on to become the highest paid lighthouse keeper in the nation, making $750 annually.

In one of her most daring rescues, two soldiers and a boy who claimed to know his way around the harbor had their boat overturned during a snowstorm. Suffering from a dreadful cold, she ran out to the rowboat without putting on her coat or shoes and rowed to the rescue. The two adults were saved, but the boy drowned before Ida could reach him. The rescue made national headlines in daily and weekly editions such as the *New York Tribune*, *Harper's Weekly*, *Putnam's Magazine* and *Leslie's Magazine*. Ida became an overnight sensation. Thereafter, her lifesaving exploits continued to receive both national and international press coverage.

During the ensuing years, Ida's feats would continue to be recognized. She became so popular that luminaries such as General Ulysses S. Grant, General William Tecumseh Sherman, General Ambrose Everett Burnside and Admiral George Dewey visited her, along with other notables who summered in Newport. At the height of her popularity, Ida's father counted over nine thousand visitors to the lighthouse in the summer of 1869. Ida even received numerous marriage proposals.

As her fame grew, so did the awards and accolades. The Life Saving Benevolent Association of New York awarded her a silver medal and $100 in cash. The city of Newport gave her "a sleek mahogany rowboat with red

velvet cushions, gold braid around the gunwales, and gold-plated oarlocks." And in 1881, Ida received the Gold Lifesaving Medal from the United States government. At the age of sixty-four, she also received a pension from the Carnegie Hero Fund that amounted to $30 a month for life. As the awards came rolling in, so did the titles. Perhaps the most illustrious was given to her by the Society of the American Cross of Honor, which called her the "Bravest Woman in America."

But her life was not all glory. Besides taking care of her disabled father, she also nursed her invalid sister and an aged mother, who eventually died of cancer in 1887. At the age of twenty-nine, she married Captain William H. Wilson of Black Rock, Connecticut. Soon they had a son, but he died at the age of two. The marriage ended in divorce about the same period. Much of Ida's time was spent in Newport, where she lived in seclusion, perhaps dictated by her dedication to her lighthouse keeping duties and her reluctance for attention as a celebrity, though she did live with her brother Rudolph on Lime Rock later in life. When asked about her isolated surroundings and austere lifestyle, she replied, "I love it. I could not be contented elsewhere."

Her final rescue took place when she was sixty-three. A close friend of hers was rowing out to visit at the lighthouse when she fell overboard. Jumping in her own boat, Ida rowed to the rescue.

Ida's career ended on October 24, 1911, at the age of sixty-nine of an apparent stroke. She had worked the lamp singlehandedly for thirty-nine years after her mother was relieved of her duties because of illness. During a time when it was considered unladylike to row boats, Ida answered the critics by saying "that none but a 'donkey' would consider it 'unfeminine' to save lives." Few could argue.

A DESIGNING WOMAN

The year was 1876, and what a year it was. First the positives: Baseball's National League was founded, and the first no-hitter was pitched in the majors; Tchaikovsky completed the ballet *Swan Lake*; Colorado became the thirty-eighth state; the Transcontinental Express train traveled from New York to San Francisco in just under eighty-four hours; and inventor Alexander Graham Bell made the first telephone call to Thomas Watson. And the negatives: African Americans rioted in the streets of South Carolina to protest racial discrimination, Native Americans were forced onto government reservations

and General George Armstrong Custer and the Seventh Cavalry would meet their fate at Little Bighorn. But another happening became one of the top news stories of 1876: an event that was held in commemoration of the 100th anniversary of the Declaration of Independence.

After ten years of planning and painstaking effort, the Centennial Exposition—formally called the International Exhibition of Arts, Manufactures and Products of the Soil and Mine—was scheduled to open in Philadelphia, Pennsylvania. Constructed on a 450-acre site at Fairmount Park along the banks of the Schuylkill River, the fair officially opened on May 10, 1876. President Ulysses S. Grant, as the guest of honor, gave a brief welcoming address. But before the visitors were allowed entrance, there was another task he had to perform. Grant was given the honor of switching on the Corliss Steam Engine that powered all the Exposition exhibits. Designed by engineer George Henry Corliss from Providence, the steam power generated by this engine was 30 percent more efficient than standard waterpower of the day. Its recent introduction into the world of manufacturing made it possible to locate new plants away from water sources such as lakes, ponds and rivers.

According to an article written by Carol McCabe and published in the *Providence Journal*, Helen Adelia Rowe Metcalf, a Providence resident, along with a group of ladies was present at the time "when all the bells in the city…began to ring" announcing the grand opening. At the time, Helen was forty-six, married to a former cotton broker turned textile manufacturer and the matriarch of a family with five children. To her credit, she was also a Sunday school teacher and an organist. Though details are sketchy, Helen and her companions appear to have been part of the official Rhode Island delegation. Over the following months, she may have traversed the fairgrounds on numerous occasions. While she was amazed at all that she saw, Helen was also disheartened at how deficient a woman's education had been in the field of practical design. But after visiting the Women's Pavilion, she felt differently. Here women were actively involved in demonstrating new products and processes, some developed and designed by the very same ladies. It is unclear how long Helen remained in Philadelphia, but what is known is the Centennial Exposition had an enormous impact on her thinking and future plans.

How much of the fair Helen actually saw is lost to posterity. With over thirty thousand domestic and international exhibitors, there was just too much to take in. Many of the exhibits were housed in several large pavilion halls, with the Main Exposition Building spanning some 21.5 acres. At the time, the temporary

structure was the largest of its kind in the world. The most memorable exhibit at the fair was Alexander Graham Bell's telephone. Perhaps no one at the time envisioned how his invention would make the world so much smaller in the not-so-distant future. Besides exhibits dealing with the arts, science, technology, manufacturing, agriculture and horticulture, attendees were treated to a new item of produce introduced for the first time in the United States: a yellow crescent-shaped fruit called a banana.

Over the ensuing months, each state was honored on separate days. "Rhode Island Day" was held on October 5. When the day arrived, the weather was cold and raw, reminiscent of the damp weather back in Rhode Island for that time of year. But the weather did not spoil attendance. By the end of the day, over 100,000 visitors had roamed the fairgrounds. Assuredly, many visited the Rhode Island House and the state's exhibits, which included jewelry, arts, machinery and agricultural products. Helen Metcalf would have been there that day making certain that the exhibits she initially set up with others offered the best representation for the state of Rhode Island.

After returning home to Providence, Helen was determined to put what she had learned to good use. Luckily, the state committee's Exposition fund (much of which came from private donations) had a surplus of $1,675. She knew it was time to act. Helen lobbied the thirty-four members of the Rhode Island Women's Centennial Committee to invest the surplus into opening a coed practical design school in Providence. Her suggestion quickly gained momentum, and on March 22, 1877, the Rhode Island School of Design (RISD) was established. The first building was located at the base of College Hill in Providence in an area known for educating young adults. RISD's neighbor was—and still is—Brown University.

Forty-three students made up RISDs first class, with the majority being women. At the school, they were taught how to design calico prints. It was an important industry in the state because the William Sprague family had dominated the world market of calico printing for several generations and employed many Rhode Islanders in its mills. Courses were also offered in jewelry, carriage and furniture design.

In the ensuing years, Helen served as the chairwoman for the school. During a seventeen-year span, she wore many hats: financial manager, personnel manager, purchasing agent, public relations liaison, policy maker and, when needed, Helen even performed janitorial duties. When her age caught up to her and she could no longer handle all the rigors associated with running the school, she transitioned the work to her daughter, Eliza Greene Metcalf Radeke, who served at RISD until 1929.

A watercolor on ivory in a fourteen-karat gold case of Helen Adelia Rowe Metcalf, circa 1895. *Courtesy of the Rhode Island School of Design Museum.*

As decades passed and the school became well known both nationally and internationally, RISD would have eighteen presidents. Today, the school boasts a full- and part-time faculty and staff of approximately 750 in sixteen undergraduate and seventeen graduate majors. Wisely, over the years, RISD and Brown University have come to share social, academic and community resources. Both schools also maintain a joint course curriculum that greatly enhances their students' educational opportunities.

RISD also has an art museum. With over eighty thousand artifacts, the RISD Museum is touted as one of the finest of its kind in the United States. Arguably, the museum has added significantly to the school's progressive and prestigious image, all in keeping with Helen's initial ideals and vision.

Recently, an article by the *U.S. News and World Report* ranked RISD as the second-best undergraduate fine arts school in the nation. But it was no runaway for first-place winner, Yale University. In two separate categories, graphic design and industrial design, RISD placed first. Adding to the luster, RISD's graduate program ranked number one for three consecutive years on the magazine's listing for art schools offering graduate programs.

Helen Adelia Rowe Metcalf died in 1895. She might never have envisioned how successful her fine arts school would become—then again, maybe she did.

A WOMAN OF INTRIGUE AND ECCENTRICITY

Her name was Doris Duke. She was called many things during her lifetime, from "the world's richest girl" to "unconventional," "secretive," "reclusive" and "eccentric." Those descriptors and more appeared to fit her image and lifestyle. Doris's time was filled with parties and handsome men: Hollywood movie stars, racecar drivers, athletes and political figures. She enjoyed social gatherings, international travel, art collecting (Islamic and Southeast Asian) and just about anything else that fit her fancy. She was also the subject of gossip columns due to her wealth and involvement in numerous scandals. But her redemption—whether desired or not—came through her dedicated work as a philanthropist, something she took quite seriously. Yet in the end, it is said she died a lonely woman.

Born in New York City on November 22, 1912, Doris was the only child of James Buchanan Duke (founder of the American Tobacco Company and the Duke Power Company) and Nanaline Holt Inman, an attractive widow of an Atlanta cotton merchant. When Doris was young, her father gave her two tidbits of advice while on his deathbed: "Trust no one" and "Deny yourself nothing." In life, she failed with the first but succeeded beyond her father's wildest dreams with the second.

When her father died in 1925, Doris and her mother inherited an enormous fortune that would be valued today at roughly $1 billion. Five years later, Doris was presented to society as a debutante at Rough Point, the family mansion along fashionable Bellevue Avenue in Newport, Rhode Island. Doris's mother passed away in 1962.

From day one, Doris was an adventurist. Some say she had a difficult time staying in one place for any length of time. But during her lifetime, she accomplished considerably more than having her passport stamped in foreign lands. Doris became a horticulturalist, a news correspondent and a serious art collector. She also spoke fluent French and on occasion performed in society as a jazz pianist. While living in Hawaii, she became a competitive surfer and, like any pretty young lady, managed to attract the opposite sex.

But it seemed that her luck with men constantly faced adversity. Doris wanted "privacy and intense intimacy" from her relationships but got neither. Twice married and twice divorced, her first marriage lasted eight years, her second but four. Though estranged from her first husband, Doris had an extramarital affair that resulted in the birth of a child. She was twenty-seven years old at the time. No one knew who fathered the child, as she had ongoing relationships with several men at the time. The baby girl

Doris Duke and her companion, C. Alan Hudson of New York. *From an original wire service photograph credited to ACME and NEA, titled "Society Attends International Polo Matches at Meadowbrook on September 12th [1931]"; now in the author's collection (FLG).*

was born prematurely and died the following day. The loss devastated Doris for the rest of her life.

A bizarre episode took place many years later when Doris, seventy-three years old at the time, met a thirty-two-year-old woman by the name

of Chandi Heffner. Doris was convinced that the girl was a reincarnation of her baby daughter. After lavishing her with expensive gifts, including a 290-acre horse ranch in Hawaii, Doris adopted her three years later. The relationship quickly soured. Doris moved to nullify the adoption in a court of law on the basis that the young woman was nothing more than a gold-digger. Doris called the episode "the greatest mistake I ever made in my life." The court agreed.

During her lifetime, Doris maintained residences in Beverly Hills, California; Honolulu, Hawaii; Duke Farms in Hillsborough Township, New Jersey (her principal residence); New York City; and Newport, Rhode Island. During the winter months, Doris resided in either of two locations: Honolulu, Hawaii, a place she named "Shangri La," or Beverly Hills, California, called "Falcon's Lair" that was once the home of Hollywood movie star Rudolph Valentino. She also maintained two fashionable apartments in Manhattan.

While at Rough Point—a forty-nine-room English manor-style mansion—Doris worked weekends in the summer for the Newport Restoration Foundation encompassing preservationist organizations she established. Had it not been for her intervention, finances, business acumen and just plain hard work, many of Newport's eighteenth- and nineteenth-century homes would not have survived. As Stephanie Mansfield said in her book *The Richest Girl in the World*, "Doris' vision and financial support had virtually changed the face of Newport." During her lifetime, Doris's efforts have been credited with saving over eighty historic structures. Over the years, rundown neighborhoods were turned into historical showcases that literally changed the complexion of the city. After a few decades, Newport had been magically transformed from a community highly dependent on the presence of the U.S. Navy into a historic architectural Mecca where travelers annually flock to visit the attractions of the "City by the Sea." Although Newport's revival was largely credited to Doris and the Newport Restoration Foundation, many other individuals and agencies also took part in the massive transformation effort, such as the Newport Historical Society, the Preservation Society of Newport County, Operation Clapboard and the Oldport Association, along with a number of private citizens and lesser-known organizations.

An important consideration to remember is that Doris's work ethic was not confined solely to mental undertakings. She never hesitated to get her hands dirty by cleaning the rooms in her homes or working outside near her gardeners. She simply loved nature and enjoyed gardening. She also cherished being away from the limelight. Accounts state that she persistently tried to

avoid the paparazzi and, by attempting to avoid detection, inadvertently popularized the wearing of sunglasses.

Arguably, Doris was an eccentric. Those who think otherwise need only to look at the facts: the strange adoption episode, maintaining a Buddhist collection on one of her estates that was said to contain the crypt of Buddha himself, allowing camels and other exotic animals to roam freely on the grounds of her Newport estate, her numerous affairs, belly dancing and singing weekends in a black gospel choir, just to name a few. But her eccentricity was easily outweighed by her philanthropic endeavors that started as far back as 1934, when, still a young girl, she established Independent Aid, Inc. The association was created to manage the numerous requests for financial support that Doris was receiving on a daily basis. The corporation was the forerunner of the Doris Duke Foundation.

After years of good health, old age caught up to her. In 1992, after taking medication for a facelift operation, she fell and broke her hip. In less than a year, she had a knee replaced that required hospitalization for two and a half months. Three months later, she underwent another knee surgery. The day after her hospital release, she suffered a severe stroke from which she never fully recovered. When she died on October 28, 1993, in Beverly Hills, California, much of her $1.3 billion fortune was left to charity. What remained unknown at the time was that during her lifetime, Doris anonymously supported many projects and charities. After her death, the Doris Duke Charitable Foundation was created to lend financial support to medical research, prevention of cruelty to children and animals, the performing arts, wildlife and ecology. The dividends from this foundation continue to bear fruit and will do so for many years to come.

SAVING A CITY

If anyone deserves credit for Providence's revitalization, it has to be Antoinette Forrester Downing. How important were her contributions? There are those who believe that as a preservationist, she singlehandedly saved the city's private homes from the wrecking ball. Though the claim is exaggerated, it does add credence to her importance in making Providence what it is today—a true renaissance city that preserved architectural gems from its past while managing to aesthetically coexist with new, more modern structures. Few cities in the United States can lay such claim. Had it not been

for her vision and the spearheading of preservation initiatives, Providence might have turned into another American city slowly dying from that dreadfully contagious disease: urban decay.

Though she preferred to be called Antoinette, her first name was Myrtle. She was born in the small town of Paxton, Illinois, on July 14, 1904. Today, the town, situated on 2.3 square miles (all land), has about 4,500 inhabitants. It is located in the mideastern part of the state, not far from the Indiana boarder. In Antoinette's day, the town's population was probably less than half its current size. Before reaching her tenth birthday, Antoinette's father died, leaving her mother to support the family. After her mother became a teacher, Antoinette resided in Texas and New Mexico, where she experienced even more solitude than in the sleepy town of Paxton. But in 1921, the future began to brighten. Antoinette had returned to Illinois to attend college at the University of Chicago, and while studying there, she met her future husband, George Elliot Downing. Both were intellectuals destined for bigger accomplishments in life. After graduating, George and Antoinette traveled to Massachusetts; she to attend Radcliffe under a fellowship, and he to secure an advanced degree from Harvard. After his graduation, they married in December 1929.

George and Antoinette honeymooned in Europe, where they toured and took in the cultural heritage of the region. After enjoying their travels, they returned to Providence, where George began a professorship in the art department at Brown University. The move proved a godsend for both, but more so for Antoinette. Surrounded by hundreds of early American homes, Antoinette acquired a taste for New England architecture. To enhance her knowledge of early American design, she took courses at the Rhode Island School of Design, where she studied under architect Norman Isham. To his credit, he had achieved over thirty years of field experience learning about seventeenth- and eighteenth-century Rhode Island buildings. Yet up until that time, few others had taken the initiative to study about Rhode Island's rich architectural history. Antoinette decided to do something about it. In 1937, she published a book that had taken five years to research, titled *Early Homes of Rhode Island*. With the success of the book, she was now being viewed as an "architectural historian" in spite of the fact that she was never trained professionally as an architect (she did take some courses in architecture at Radcliffe College) or as an antiquarian.

In the late 1930s and most of the 1940s, Antoinette raised a family and taught school. Though still fascinated with century-old homes, she remained out of the limelight—that is, until the late 1940s, when she began working

A detailed image of Antoinette Downing. *Courtesy of the Rhode Island Historical Preservation & Heritage Commission.*

for the Preservation Society of Newport County. The newly founded organization had dedicated itself to preserving the century-old houses on Aquidneck Island.

But the real preservation initiative did not commence until the 1950s, when Brown University and the Rhode Island School of Design wanted to construct new dormitories on Providence's East Side, known as College Hill.

To do so, a number of eighteenth- and nineteenth-century buildings would have to be demolished. Many of the existing structures were in deplorable condition, and therefore, the decision to move forward with the project seemed like an appropriate course of action, but not to Antoinette. That is when her passive interest turned into determined activism. Joining with other residents from the area, in 1955, she helped organize the Providence Preservation Society along with John Nicholas Brown, who came up with the original idea. (A descendant of the benefactor of Brown University, John Nicholas Brown was interested not only in Brown University's expansion but also in preserving the city's old houses.) Working together in 1959, the group drafted a report titled "College Hill, A Demonstration Study of Historic Area Renewal." It would serve as the framework for the restoration of the neighborhood that eventually became a national model for historic preservation.

In a *New York Times* article titled "Her Mission Is Preserving Providence" by Judy Klemesrud, Antoinette is quoted as saying, "In a small state like this, once you become associated with something, you're asked to do things forever." And she was right, even if it meant taking heavy-handed criticism. In the beginning, she had made a name for herself, but not in the way she anticipated or desired. During the College Hill dormitory fiasco, there were those who called her "crazy" and a "meddler." While chaperoning a party at Brown University with her husband, she was verbally abused by those who felt that she was "fighting education." Of course, wearing tennis shoes all the time, when such footwear was considered unladylike and unfashionable, probably did not add favorably to her image.

In the end, Antoinette and her group won not only the battle but also the war. The College Hill Historic District was established in 1960. By 1980, over $20 million has been invested in restoring 750 houses in the area. One lady (Beatrice "Happy" Chace) put her money where her mouth was by buying and restoring 15 houses in the neighborhood. The block is now called Happy Land.

Antoinette did have a single regret about the College Hill project, and that was that by preserving the houses, many poor families were displaced. Even years later, she would be greeted by "hostile students" during her annual lecture on the Brown University campus. Trying to clarify her position to a newspaper correspondent, she said, "Each year I go, I think I'm going to be able to explain it. If the houses on Benefit Street hadn't been renovated, they would have been demolished."

As time progressed, other old houses throughout the city were bought and remodeled. By Antoinette's own account, several thousand old homes

had been preserved in Providence since the 1950s. The city now stands as one of a handful of metropolitan areas that contain the largest collection of century-old houses. And to think, Providence was once called "Boston's ugly stepsister."

Antoinette died at the age of ninety-six on May 9, 2001, outliving her husband, George, by twenty-four years. During her lifetime, she received many awards and honorary degrees. Today, her lasting legacy and the fruits of her work can be seen in many areas of Providence, especially along Benefit Street's Historic Mile, where numerous restored houses add to the illustrious character of the historic district.

RESOURCE INFORMATION AND AUTHOR NOTES

1. NATIVE AMERICANS

THE HARD LIFE OF AN INDIAN SQUAW

The authors found the book *Wampanoag Cultural History: Voices from Past and Present*, by Frank Waabu O'Brien and Strong Woman (Julianne Jennings), a worthy and enlightening reference. Three other books are also recommended for further reading: *Massasoit*, by Alvin G. Weeks; *Sachems of the Narragansetts*, by Howard N. Chapin; and *The Narragansett*, by William S. Simmons.

2. ACTIVISTS, REFORMERS AND DORRITES

DORRITES IN PETTICOATS

In 1880, Sidney Rider published in his *Rhode Island Historical Tracts* (#11) a brief account of the lives of both Catherine Williams and France H. Whipple Greene McDougal. In 2004, Sarah O'Dowd published *A Rhode Island Original*, a full-length biography of McDougal. There has never been a published account of either Ann Parlin or Abby Lord.

A FOOTPRINT ON THE EARTH

References used for this essay included: *The Portable Margaret Fuller*, edited by Mary Kelly; John Matteson's *The Lives of Margaret Fuller*; and Judith Strong Albert's "Margaret Fuller's Row at the Greene Street School: Early Female Education in Providence, 1837–1839," published in *Rhode Island History* 42, no. 2 (May 1983).

A SOWER OF SEEDS
Sources for this story include Lillie B. Chace Wyman and Arthur C. Wyman's *Elizabeth Buffum Chace: Her Life and Its Environment*; Elizabeth C. Stevens's *Elizabeth Buffum Chace and Lillie Chace Wyman—A Century of Abolitionist, Suffragist and Worker's Rights Activism*; and Sara M. Algeo's *The Story of a Sub-Pioneer*.

TRY, TRY AGAIN
For further reading, the authors recommend two books: *Elizabeth Buffum Chace, 1806–1899: Her Life and Letters*, written by Lillie Buffum Chace Wyman and Arthur Crawford Wyman, and *Elizabeth Buffum Chace and Lillie Chace Wyman: A Century of Abolitionist, Suffragist and Worker's Rights Activism*, written by Elizabeth C. Stevens. A concise history of the suffrage movement can be found on the Internet under the title "Records of the League of Women Voters of Rhode Island," posted by the Rhode Island Historical Society. The original incorporation papers for the Rhode Island Women's Suffrage Association can be viewed at the Rhode Island State Archives in Providence.

3. THE LITERATI

QUOTH THE ENGAGEMENT, NEVERMORE
Much can be found about Sarah's life and her ties to Poe on several Internet sites. Sarah's defense of Poe in her book *Edgar Allan Poe and His Critics* can be read online.

WARMING BOTH HANDS BEFORE THE FIRE OF LIFE
To learn more about Maud's views about Aquidneck Island, the reader is encouraged to peruse Maud's book *This Was My Newport*. A recent biography by Nancy Whipple Grinnell, titled *Carrying the Torch: Maud Howe Elliott and the American Renaissance*, offers fascinating insights and a fresh perspective about Maud's passion for social reform and the arts.

4. ARTS AND ARTISTS

IN HER FATHER'S FOOTSTEPS
For further reading, the authors recommend Charlotte Streifer Rubinstein's book *American Women Artists* and Meg Nola's article on the web titled "American Artist Jane Stuart, Daughter of Painter Gilbert Stuart."

THE GIRL WITH BIG DREAMS
The Matthew Rodrigues interview with Viola Davis can be viewed on YouTube. Viola's address at Central Falls High School as reported by Erika

Niedowski on May 24, 2012, can be viewed on the Huffpost Celebrity website, titled "Viola Davis, Central Falls High School: Actress Addresses Class of 2012 at Alma Mater." As for the town of Central Falls, its future may be brighter. The citizens recently elected five women to a newly expanded town council. Each woman comes with a well thought-out vision and steadfast determination to improve the municipality.

5. EDUCATORS

A LASTING LEGACY

The best account of Sarah Doyle's life and her involvement in the women's movement can be found in *The Search for Equality*, edited by Polly Welts Kaufman. While this book is a collection of essays by various authors focused on women at Brown University from 1891 to 1991, it does contain accounts of Sarah's other reform efforts. Also of note is the short article "A Sphere 'With an Infinite Radius,'" by Gina Macris, published in the *Providence Journal*, March 16, 1994. See also *Pembroke College in Brown University 1891–1966*, by Grace E. Hawk. In Charles Carroll's *Rhode Island: Three Centuries of Democracy* is an important chapter titled "Women's Part in Making Rhode Island," with accounts of education of women and women's clubs. While this chapter is not specific to Sarah, it provides an excellent overview of those efforts that occupied much of Sarah's time.

AN EDUCATIONAL VISIONARY

The Rhode Island Heritage Hall of Fame website includes a brief but informative biography about Mary and her contributions to American education during the nineteenth and twentieth centuries. Information about the spy episode and Mary's trips to France was obtained from Robert Martin of the Wheeler School through e-mail. To learn more about the Mary C. Wheeler School, visit the school's website.

OUT OF NECESSITY

Little is written about Katharine Gibbs's life. Her story and that of the school are found in several short accounts; of note is the short article "'Very Proper Ladies' Start a Small School," by Katherine Imbrie, published in the *Providence Journal* on March 18, 1994, and an introduction to the Katharine Gibbs School records in the archives at the John Hay Library, Brown University.

ENTERPRISING WOMEN

The best account in book form is *Johnson & Wales: A Dream That Became a University*, by Donald A. D'Amato and Rick Tarantino. Also of note is the short

article "'Very Proper Ladies' Start a Small School," by Katherine Imbrie, published in the *Providence Journal* on March 18, 1994. Recently, Good Night Irene Productions, an independent film company, produced a documentary entitled *HERstory: The Founding Mothers of Johnson & Wales University*. This documentary is part of a trilogy of films under the title *A University Comes of Age*. The filmmaker is Marion Gagnon, who is also a full-time professor in the School of Arts & Science at Johnson & Wales University.

6. RELIGIOUS LEADERS

A QUAKER MARTYR

For more in-depth coverage, the authors recommend Ruth Talbot Plimpton's enlightening book *Mary Dyer: Biography of a Rebel Quaker*. Also referenced for this work was Linda Borg's article published in the *Providence Journal* titled "Abiding Faith Brings Death on Gallows." The *Providence Journal* also published a feature article about Mary's life in its Sunday edition of March 2, 2014. When taken at face value, the word "Puritan," in some respects, is a misnomer. Though Puritans had many unorthodox beliefs, the reader may be surprised by some of their contradictions. To learn more, the reader is encouraged to review a plethora of Internet articles about their religious convictions.

THE PUBLICK UNIVERSAL FRIEND

Still the best source for information on the life and ministry of Jemima Wilkinson, even though it was published some fifty years ago, is the work *Pioneer Prophetess*, by Herbert A. Wisbey Jr. Wisbey also wrote a short article, "Plagiarism by a Prophetess," concerning a book ascribed to the Publick Universal Friend published in *Rhode Island History* 20, no. 3 (July 1961). Another essay about Jemima that is worth reading is titled *Notable American Women: A Biographical Dictionary* (1971). A rare and difficult-to-find 1821 account discrediting Jemima's ministry was written by David Hudson, titled *History of Jemima Wilkinson*. A more available account also discrediting Jemima can be found in Barbara Mills's *Providence 1630–1800, Women Are Part of Its History*. *Women and Religion in America, Vol. 2: The Colonial and Revolutionary Periods*, edited by Rosemary R. Ruether and Rosemary S. Keller, provides additional insight into Jemima's ministry.

7. MAKING THEIR VOICES HEARD

FROM INDENTURED SERVANT TO ENTREPRENEUR

Memoirs of Elleanor Eldridge, written by Frances H. Green, is digitized and can be read online. For further reading, the authors recommend two books: *The*

Cambridge History of African American Literature, edited by Maryenna Graham and Jerry W. Vard Jr., and *African-American Business Leaders & Entrepreneurs,* by Rachel Kranz.

A Hair Doctress and Abolitionist

In 2003, Christiana Carteaux Bannister was inducted into the Rhode Island Heritage Hall of Fame. Details taken from her induction brief were used in preparing this essay, along with information extracted from an article appearing in the *Providence Journal* dated March 10, 1999, by Karen A. Davis, titled "A Supporter of Arts and Social Causes." A website article titled "Christiana Bannister Biography" was also referenced.

Born Too Soon

For this essay, the authors referenced several websites: American Treasures of the Library of Congress, Matilda Sissieretta Jones—Encyclopedia Britannica and Find-A-Grave. For further reading, the authors recommend two books: *Africana: The Encyclopedia of the African and African American Experience,* edited by Kwame Anthony Appiah and Louis Gates Jr., and *A History of African American Theatre,* by Hill and Hatch. There is also a wealth of material about African American performers that can be found on the Internet that make for informative and enjoyable reading. In addition, the *Providence Journal* published a feature article in its March 15, 1994 edition, titled "She Sang for Kings, Died in Poverty."

8. Athletes

Rising to the Challenge

Numerous books have been written about Annie's exploits, and perhaps, there is none better than her own: *High Mountain Climbing in Peru & Bolivia.* For this story, the author also extracted information from the following websites: "Annie Smith Peck," by Dr. Russell A. Potter, and "Annie Smith Peck: Biography" from Answers.com.

The Queen of Baseball

This essay was written with the help of the following sources: a *Providence Journal* article, published on March 29, 1994, titled "First Baseman Shone in Semipro Ball," by Carolyn Thornton; a *Sports Illustrated* article by John Hanlon dated June 21, 1965, titled "Queen Lizzie Plays First Base"; and a website article from the Warren Athletic Hall of Fame, titled "Lizzie 'Spike' Murphy (Old Timer, Charter Class of 1998, Posthumous.)"

"THE FEMALE BOBBY JONES"

During her lifetime, Glenna authored two books: *Golf for Young Players* and *Ladies in the Rough*. For this story, the authors made use of several websites: Christopher D. Sarpy's article, titled "Glenna Collett-Vare"; Brent Kelley's article, titled "Biography of Golfer Glenna Collett Vare" on About.com: Golf; and David Wallechinsky and Irving Wallace's Trivia-Library.com, "Biography of Golfer and Athlete Glenna Collett Vare."

A DIAMOND IS A GIRL'S BEST FRIEND

Wilma Briggs's lively interview with the *Providence Journal* can be seen by searching "Wilma Briggs, *Providence Journal* Interview" on the Internet. More definitive history about the All-American Girls Professional Baseball League can be found by searching any of several websites concerning women's professional baseball. All are informative.

ALL THAT GLITTERS

The women featured in this story have been inducted into the Rhode Island Heritage Hall of Fame. Their exploits are fully detailed in the organization's website. Elizabeth Beisel's story was extracted from information obtained from the USA Swimming National Team website.

9. IT'S A WOMAN'S JOB, TOO

FEMALE PRINTERS OF NOTE

Little is written about the lives of Ann Franklin or Sarah Goddard. In Isaiah Thomas's important work *The History of Printing in America*, published in 1810, only a brief paragraph was included to describe Ann and Sarah's contributions to the field of printing. An early article, "Ann Franklin, Printer," by Howard Chapin, appeared in the *American Collector* in 1926. A more robust treatment of Ann was written by Margaret Land Ford in *Printing History* 13, no. 3, in 1990 under the title "A Widow's Work: Ann Franklin of Newport, Rhode Island." An account of Sarah by Nancy Fisher Chadacoff appeared titled "Woman in the News 1762–1770: Sarah Updike Goddard," in *Rhode Island History* 32, no. 4, published in 1973. Also, Ward Miner's book, *William Goddard, Newspaperman*, contains useful information about Sarah, as does Barbara Mills's *Providence 1630–1800, Women Are Part of Its History*.

LIVING IN INTERESTING TIMES

The major source for this story was the book *Caty: A Biography of Catharine Littlefield Greene*, by John and Janet Stegeman.

THE PRISONER'S FRIEND
There is almost nothing written on the life of Sophia Little other than a short entry in Appleton's *Cyclopedia of American Biography*, an obituary notice in a local Newport newspaper written the day of her death and a four-page "In Memoriam" published in the annual report of the Prisoner's Aid Association for 1894. In a way, it seems fitting that as a woman of modest means, she would avoid becoming the center of attention.

10. FIRST LADIES IN THEIR FIELDS

THE CHILDREN'S FRIEND
The only book-length account of Harriet was published by George Whitney in Providence in 1850 as *A Memoir of Harriet Ware*. Though the book does not list an author, it has been attributed to Francis Wayland, Baptist minister and president of Brown University and a friend of Harriet. The book was republished in 1853 by the American Sunday School Union. Both books are essentially identical and contain the only surviving correspondence by Harriet. Also worth reading is the article "India Point's First Schoolmarm," by William Joyce, published in the *Rhode Islander* of December 26, 1971.

A DEDICATED LIFE OF SOCIAL REFORM
Reverend Spencer's papers concerning her activities in the peace movement can be found at the Swarthmore College Library in the Peace Collection, titled "Anna Garlin Spencer, 1830–1931," (Collection: DG 034.) A microfilm edition, titled "The Papers of Anna Garlin Spencer [1830–1870], 1878–1931," can be obtained from Scholarly Resources Inc., ISBN: 0-8420-4340-3. For further reading about the Ms. Catt and the FBI's monitoring of her affairs, the authors recommends the following Internet website: "Carrie Chapman Catt: Girlhood Home," by the National Nineteenth Amendment Society.

A MEDICAL BREAKTHROUGH
Prior to Dr. Tyng, two women working in the medical profession (neither from Rhode Island) are worthy of note: Harriett Hunt became the first woman to practice medicine with "marked success" in America (1835), and Elizabeth Blackwell of English descent journeyed to America and achieved the distinction of becoming the first woman in America to earn a medical degree (1849). To learn more about Dr. Tyng, the authors recommend a website article titled "Another Trailblazing Jacksonville Suffragist: Dr. Anita Tyng." Also, a brief memorial tribute to Dr. Tyng, written by Dr. George D. Hersey, is also worth reading online. Titled "Anita E. Tyng, M.D.: An Appreciation," it was published in the *Providence Medical Journal*. If you're

curious, the patient who survived the removal of her ovaries was killed by an automobile while crossing a street in Providence in October 1914.

MOTHER, ENGINEER AND INDUSTRIAL PSYCHOLOGIST
Several Internet articles about the Gilbreths are worth reading. One in particular, "Women's Intellectual Contributions to the Study of Mind and Society: Lillian Moller Gilbreth (1878–1972)," offers an interesting perspective. Laura Meade Kirk's article published in the March 24, 1999 edition of the *Providence Journal* is also highly informative. It is titled "A Career of Firsts for Mother of 12." The essay that hits closest to home was written by Jane Lancaster and is titled "Frank and Lillian Gilbreth Bring Order to Providence: The Introduction of Scientific Management at the New England Butt Company, 1912–13." The article is a thoroughly researched and fascinating account of the Gilbreths' days in Rhode Island. It can be found in *Rhode Island History* 55, no. 2 (May 1997).

A NATURAL PROGRESSION
For this essay, the authors referenced a two-page autobiography (circa 1955) that is included in the Isabelle Ahearn O'Neill collection at the Rhode Island Historical Society (catalogue number: MSS 1077, box 1, folder 1). Two articles about Isabelle were also researched: "Isabelle Ahearn O'Neill: Little Rhody's Lone Theodora," by Mary Carey McAvoy, *Woman's Voice* 26, no. 8 (March 1931), and "Women Wielding Power: Pioneer Female State Legislators," hosted on the Internet. A book by Emily Stier Adler and J. Stanley Lemons titled "The Elect: Rhode Island's Women Legislators, 1922–1990," offers a fairly comprehensive biography of Isabelle.

YOU ARE NOW A "PERSON"
To learn more about Ada—of whom only scant information remains—the authors recommend an essay written by Denise Aiken, titled "Ada L. Sawyer: The Providence Portia," published in the spring 2011 edition of the *Roger Williams University Law Review*. Also, two *Providence Journal* articles, the first published on November 14, 1920, which announced Ada's acceptance to the state bar, and the second, published on May 14, 1985, her obituary, provide additional insight.

THE SOFT-SPOKEN JUDGE
Original source material for this story came from several Internet sites: Capitolwords, in an article titled "Justice Florence K. Murray: 40 Years of Excellence," written by Senator Claiborne de Borda Pell; another by the *Christian Science Monitor*, titled "Justice Florence Murray Chose the Low-Key Road to Success"; and the third by the National Association of

Women Judges, titled "NAWJ Awards Descriptions." Additional details were abstracted from a doctoral dissertation by Marian Mathison Desrosiers, titled "Justice Florence Kerins Murray: A Study of Technology and the Contemporary Woman," and a *Providence Journal* obituary about Florence's passing dated March 30, 2004.

A SPIRITED WOMAN

The following Internet articles were referenced for this story: "A Legend for Our Times," by Steve Behrens and published on Current.org; "Susan Farmer, Rhode Island Politician and PubTV Exec, Dies at 71," by Andrew Lapin and also published on Current.org; "Susan Farmer, Trailblazer for Women in Rhode Island Politics, Dies at 71," by Richard C. Dujardin, published on providencejournal.com; and the Rhode Island Heritage Hall of Fame inductee: Susan L. Farmer. Worth viewing is an online *Providence Journal* video from a May 2009 interview with Sandor Bodo in which Susan reflects about her illness, friendships and career.

11. OTHER ACHIEVERS

"THE BRAVEST WOMAN IN AMERICA"

The primary source for this story was Lenore Skomal's brief biography of Ida Lewis, *The Keeper of Lime Rock*. The authors also used information contained in the website titled "U.S. Department of Homeland Security, United States Coast Guard." A *Providence Journal* article dated March 11, 1994, titled "The Keeper of the Lime Rock Light," by Elizabeth Abbott, was also referenced. The original Lime Rock Lighthouse beacon can be seen at the Museum of Newport History at the Brick Market in Newport.

A DESIGNING WOMAN

A primary source for this essay included an article published in the *Providence Journal* by Carol McCabe, titled "Expo Inspires School for 'Useful Arts.'" The following website articles were also used: "Rhode Island School of Design," from Wikipedia; "*US News* Full List of Top Fine Arts Schools"; and "The Centennial Exposition of 1876. U.S. Grant: Warrior. WGBH American Experience: PBS." As an aside, the Smithsonian Arts and Industries Building in Washington, D.C., continues to house many of the exhibits that were originally on display at the Centennial Exposition. The collection encompasses exhibits from the United States and thirty-four foreign nations. After the fair closed, several buildings were relocated within and outside the state of Pennsylvania. At least four still remain standing on the original fairgrounds. The Rhode Island Building that stood majestically for nearly

fifty years was demolished sometime after 1921. Also worthy of note, the RISD Museum in Providence has a breathtaking collection of paintings and other exhibits for an institution of its size and stature. A painting from the collection is displayed on the front cover of this book.

A Woman of Intrigue and Eccentricity

A plethora of books have been written about Doris over the years. The authors recommend three in particular: *The Richest Girl in the World,* by Stephanie Mansfield: *Trust No One: The Glamorous Life and Bizarre Death of Doris Duke,* by Ted Schwarz and Tom Rybak; and *Daddy's Duchess: The Unauthorized Biography of Doris Duke,* by Tom Valentine and Patrick Mahn. As with any book about an international socialite, readers should judge the merits of the contents using their own discretion. For more information about Newport's architectural revival, the authors recommend *Rhode Island: A History*, by William G. Loughlin.

Saving a City

Richard Longstreet's article "Antoinette Forrester Downing, 14 July 1904–9 May 2001," published in the *Journal of the Society of Architectural Historians,* was a significant aid while writing this essay. Also, the *New York Times* article by Judy Klemesrud titled "Her Mission is Preserving Providence" provided many interesting anecdotes, some of which are reproduced in the story. Antoinette's papers are currently preserved at the Rhode Island Historical Society, Manuscript Division, catalogue number MSS 98.

BIBLIOGRAPHY

BOOKS

Abbott, Lynn, and Doug Seroff. *Out of Sight: The Rise of African American Popular Music, 1889–1895.* Jackson: University Press of Mississippi, 2003.

Adler, Emily Stier, and J. Stanley Lemons. *The Elect: Rhode Island's Women Legislators, 1922–1990.* Providence: League of Rhode Island Historical Societies, 1990.

Algeo, Sara M. *The Story of a Sub-Pioneer.* Providence, RI: Snow & Farnham, 1925.

Alsop, Gulielma Fell. *History of the Woman's Medical College, Philadelphia, Pennsylvania, 1850–1950.* Philadelphia: Lippincott, 1950.

Anthony, Mary B., and Grace P. Chapin. *A History of the Young Ladies' School, 1860–1898.* Providence: Akerman-Standard Company, 1932.

Appiah, Kwame Anthony, and Henry Louis Gates Jr., eds. *Africana: The Encyclopedia of the African and African American Experience.* New York: Oxford University Press, 2005.

Carroll, Charles. *Rhode Island: Three Centuries of Democracy.* New York: Lewis Historical Publishing Co., 1932.

Chapin, Howard M. *Sachems of the Narragansetts.* Providence: Rhode Island Historical Society, 1931.

Collett, Glenna. *Golf for Young Players.* New York: Little, Brown and Company, 1926.

———. *Ladies in the Rough.* New York: Alfred A. Knopf, 1928.

D'Amato, Donald A., and Rick Tarantino. *Johnson & Wales: A Dream That Became a University.* Virginia Beach, VA: Donning Company, 1998.

Desrosiers, Marian Mathison. *Justice Florence Kerins Murray: A Study of Technology and the Contemporary Woman*. Newport, RI: Salve Regina University (ProQuest Co. printers), 2004.

Edwards, James T., et al. *Notable American Woman—A Biographical Dictionary*. Cambridge, MA: Belknap Press, 1971.

Elliott, Maud Howe. *This Was My Newport*. Cambridge, MA: Cambridge University Press, Inc., 1944.

Graham, Maryenna, and Jerry W. Vard Jr., eds. *The Cambridge History of African American Literature*. Cambridge, MA: Cambridge University Press, 2011.

Green, Frances H. *Elleanor's Second Book*. Providence: B.T. Albro, 1842.

———. *Memoirs of Elleanor Eldridge*. Providence: B.T. Albro, 1838.

Grinnell, Nancy Whipple. *Carrying the Torch for Maud Howe Elliott: The American Renaissance*. Lebanon, NH: University Press of New England, 2014.

Hawk, Grace E. "Pembroke College." In *Brown University: The First Seventy-five Years, 1891–1966*. Providence: Brown University Press, 1967.

Hill, Errol, and James Vernon Hatch. *A History of African American Theatre*. Cambridge, MA: Cambridge University Press, 2011.

Hollander, Phyllis. *One Hundred Greatest Women in Sports*. New York: Putnam Publishing Group, 1977.

Kaufman, Polly Welts, ed. *The Search for Equity*. Hanover, NH: Brown University Press; distributed by University Press of New England, 1991.

Kelly, Mary, ed. *The Portable Margaret Fuller*. New York: Penguin Books, 1994.

Krantz, Rachel. *African-American Business Leaders and Entrepreneurs*. New York: Facts on File, Inc., 2004.

Loughlin, William G. *Rhode Island: A History*. New York: W.W. Norton & Company, Inc., 1978.

Magnus, Marilyn. *Annie Smith Peck: Queen of the Climbers*. New York: Macmillan/McGraw-Hill, 1997.

Mansfield, Stephanie. *The Richest Girl in the World: The Extravagant Life and Fast Times of Doris Duke*. New York: G.P. Putnam's Sons, 1992.

Matteson, John. *The Lives of Margaret Fuller*. New York: W.W. Norton & Co., 2012.

Mazel, David, ed. *Mountaineering Women: Stories by Early Climbers*. College Station: Texas A&M University Press, 1994.

Mills, Barbara. *Providence 1630–1800: Women Are Part of Its History*. Bowie, MD: Heritage Books, 2002.

Miner, Ward. *William Goddard, Newspaperman*. Durham, NC: Duke University Press, 1962.

Nettles, Darryl Glenn. *African American Concert Singers Before 1950*. Jefferson, NC: McFarland & Co., 2003.

O'Dowd, Sarah. *A Rhode Island Original*. Hanover, NH: University of New England Press, 2004.

Olds, Elizabeth Fagg. *Women of the Four Winds*. Boston: Mariner Books, 1998.

Peck, Annie Smith. *Annie Smith Peck, 1850–1935: The South American Tour*. London: Holden and Stoughton, 1914.

———. *High Mountain Climbing in Peru & Bolivia*. London: New York: Mead and Company, 1911.

Plimpton, Ruth Talbot. *Mary Dyer: Biography of a Rebel Quaker*. Boston: Branden Publishing Co., 1994.

Rubinstein, Charlotte Streifer. *American Women Artists*. New York: Avon Press, 1986.

Ruether, Rosemary R., and Rosemary S. Keller, eds. *Woman and Religion in America*. Vol. 2, *The Colonial and Revolutionary Periods*. New York: Harper & Row, 1983.

Schwarz, Ted, and Tom Rybak. *Trust No One: The Glamorous Life and Bizarre Death of Doris Duke*. New York: St. Martin's Press, 1997.

Simmons, William S. *The Narragansett (Indians of North America)*. New York: Chelsea House Publishers, 1989.

Skomal, Lenore. *The Keeper of Lime Rock*. Philadelphia: Running Press Book Publishers, 2002.

Stegeman, John F., and Janet A. *Caty: A Biography of Catherine Littlefield Greene*. Providence: Rhode Island Bicentennial Foundation, 1977.

Stevens, Elizabeth C. *Elizabeth Buffum Chace and Lillie Chace Wyman: A Century of Abolitionist, Suffragist and Worker's Rights Activism*. Jefferson, NC: McFarland & Co., 2003.

Story, Rosalyn M. *And So I Sing: African-American Divas of Opera and Concert*. New York: Grand Central Publishing, 1990.

Thomas, Isaiah. *The History of Printing in America*. New York: Weathervane Books, 1970.

Valentine, Tom, and Patrick Mahn. *Daddy's Duchess: The Unauthorized Biography of Doris Duke*. Secaucus, NJ: Lyle Stuart Inc., 1987.

Wayland, Francis. *A Memoir of Harriet Ware*. Providence: George Whitney, 1850.

Weeks, Alvin G. *Massasoit*. Norwood, MA: Privately printed by Plimpton Press, 1920.

Whitman, Sarah Helen. *Edgar Allan Poe and His Critics*. Whitefish, MT: Kessinger Publishing, LLC, 2004.

Williams (Wheeler), Blanche E. *Mary C. Wheeler: Leader in Art and Education*. Boston: Marshall Jones Co., 1934.

Wisbey, Herbert A. *Pioneer Prophetess*. Ithaca, NY: Cornell University Press, 1964.

Wyman, Lillie Buffum Chace, and Arthur Crawford Wyman. *Elizabeth Buffum Chace, 1906–1899: Her Life and Its Environment*. Boston: W.B. Clark Co., 1914.

Electronic Sources

Behrens, Steve. "A Legend for Our Time." *Current*, December 16, 1991. http://www.current.org/1991/12/farmer123.

"The Centennial Exposition of 1876. U.S. Grant: Warrior. WGBH American Experience / PBS." No posting date. http://www.pbs.org/wgbh/americanexperience/features/general-article/grant-exposition.

Christian Science Monitor. "Justice Florence Murray Chose the Low-Key Road to Success." No posting date. http://www.csmonitor.com/1984/0105/010507/.html/(page)/2.

Dujardin, Richard C. "Susan Farmer, Trailblazer for Women in Rhode Island Politics, Dies at 71." Providencejournal.com, September 16, 2013. http://www.providencejournal.com/breaking-news/content/20130916-susan-farmer-trailblazer-for-women-in-rhode-island-politics-dies-at-71.ece.

E-mail messaging between Robert Martin of the Wheeler School and the author (FLG) on February 13, 2014.

Lapin, Andrew. "Susan Farmer. Rhode Island Politician and PubTV Exec, Dies at 71." *Current*, September 20, 2013. http://www.current.org/2013/09/susan-farmer-rhode-island-politician-and-pubtv-exec-dies-at-71.

Metro Jacksonville. "Another Trailblazing Jacksonville Suffragist: Dr. Anita Tyng," April 21, 2011. http://www.metrojacksonville.com/forum/index.php?topic=11963.0.

National Association of Women Judges. "NAWJ Awards Descriptions." No posting date. http://www.nawj.org/awards_descriptions.asp.

National Nineteenth Amendment Society. "Carrie Chapman Catt: Girlhood Home." No posting date. http://www.catt.org.

Nola, Meg. Santa Cruz Community Media Lab. "American Artist Jane Stuart, Daughter of Painter Gilbert Stuart," June 30, 2010. https://suite.io/meg-nola/3sww2fk.

Pell, Claiborne de Borda, Sen. Capitolwords. "Justice Florence K. Murray—40 Years of Excellence," May 13, 1996. http://capitolwords.org/date/1996/05/13/S4959_justice-florence-k-murray-40-years-of-excellence.

Rhode Island Heritage Hall of Fame. "Susan L. Farmer: Inducted 2010." No posting date. http://www.riheritagehalloffame.org/inductees_detail.cfm?iid=665.

Scholarly Resources Inc. "The Papers of Anna Garlin Spencer [1830–1870], 1878–1931," on microfilm, ISBN: 0-8420-4340-3. http://microformguides.gale.com/Data/Download/8385000C.pdf.

Wikipedia, the Free Encyclopedia (various articles).

"Women's Intellectual Contributions to the Study of Mind and Society: Lillian Moller Gilbreth (1878–1972)." No posting date. http://www2. webster.edu/~woolflm/gilbreth2.html.

LIBRARY COLLECTIONS

Rhode Island Historical Society: "Antoinette Downing Papers," (Collection number: MSS 98)

Swarthmore College Library. Peace Collection: "Anna Garlin Spencer, 1830–1931," (Collection: DG 034).

MISCELLANEOUS (ARTICLES, JOURNALS, NEWSLETTERS, PAMPHLETS, REPORTS AND REVIEWS)

Adler, Emily Stier, and J. Stanley Lemons. "The Independent Woman: Rhode Island's First Woman Legislator." *Rhode Island History* 49, no. 1 (February 1991).

Aiken, Denise. "Ada L. Sawyer: The Providence Portia." *Roger Williams University Law Review* 16, no. 2 (spring 2011).

Albert, Judith Strong. "Margaret Fuller's Row at the Greene Street School: Early Female Education in Providence, 1837–1839." *Rhode Island History* 42, no. 2 (May 1983).

Brown, George T. (Bud), ed. "Sports Legends in Rhode Island: Glenna Collett Vare—First Lady of American Golf." *Old Rhode Island* 4, issue 7 (reprinted from *Golf: The Money Swing*).

Ford, Margaret Land. "A Widow's Work: Ann Franklin of Newport, Rhode Island." *Printing History* 13, no. 3 (1990).

Hersey, George D., PhD. "Anita E. Tyng, M.D.—An Appreciation." *Providence Medical Journal* 17 (1916).

"In Memoriam." *Annual Report of the Prisoner's Aid Association* (1894).

Joyce, William. "India Point's First Schoolmarm." *Rhode Islander*, December 26, 1971.

Kirk, Laura Meade. "A Career of Firsts for Mother of 12." *Providence Journal*, March 24, 1999.

Klemesrud, Judy. "Her Mission Is Preserving Providence." *New York Times*, May 2, 1985.

Lancaster, Jane. "Frank and Lillian Gilbreth Bring Order to Providence: The Introduction of Scientific Management at the New England Butt Company, 1912–13." *Rhode Island History* 55, no. 2 (May 1997).

Longstreet, Richard. "Antoinette Forrester Downing, 14 July 1904–9 May 2001." *Journal of the Society of Architectural Historian* 61, no. 2 (June 2002): 260–62.

McCabe, Carol. "Expo Inspires School for 'Useful Arts.'" *Providence Journal*, March 14, 1999.

Various writers. "Women in R.I. History: Making a Difference." *Providence Journal Co.*, March 1994.

NEWSPAPERS AND MAGAZINES

Frank Leslie's Illustrated Newspaper
Harper's Weekly
Newport Daily News
New York Herald
New York Times
Providence Evening Bulletin
Providence Journal
Spokane Daily Chronicle
U.S. News and World Report

INDEX

ABOUT THE AUTHORS

Friends for over three decades, Frank L. Grzyb and Russell J. DeSimone have individually written numerous books and articles concerning Rhode Island history. Born in Massachusetts, Frank has also written about America's Civil War and the Vietnam Conflict. His works have achieved both regional and national recognition. A Rhode Island native, Russell is a leading scholar on the Dorr Rebellion. Recently, he produced a critically acclaimed documentary film about the little-known historic event that not only affected Rhode Island citizens but also impacted voter rights on the national scale that resonates to this day.

Both Frank and Russell are featured speakers on the lecture circuit. This book is their first collaboration.

CPSIA information can be obtained
at www.ICGtesting.com
Printed in the USA
BVHW040737300119
538840BV00017BA/849/P